IMAGES
*of America*

# KENTUCKY'S
# BLUEGRASS MUSIC

IMAGES
*of America*

# KENTUCKY'S
# BLUEGRASS MUSIC

James C. Claypool

ARCADIA
PUBLISHING

Published by Arcadia Publishing
Charleston, South Carolina

Printed in the United States of America

Library of Congress Control Number: 2009938221

For all general information contact Arcadia Publishing at:
Telephone 843-853-2070
Fax 843-853-0044
E-mail sales@arcadiapublishing.com
For customer service and orders:
Toll-Free 1-888-313-2665

Visit us on the Internet at www.arcadiapublishing.com

*This book is dedicated to my son, Jim, my daughter, Susan, and
to my grandchildren, Brittany, Jamie, Allsun, and Jack.*

# CONTENTS

# ACKNOWLEDGMENTS

A number of people have provided great assistance and are to be thanked for their roles in helping to bring this book to press. Thanks is owed to Ed Commons of *The Red Barn Radio Show* in Lexington, Kentucky; to bluegrass musician Gene Thompson of Hebron, Kentucky; to musician Eddie Chipman of Dry Ridge, Kentucky; and to Tony Tackett, director of the Highway 23 Museum in Paintsville, Kentucky, for providing a number of quality pictures. Bluegrass musician Vernon McIntyre and *Bluegrass Unlimited* editor Sharon McGraw also provided several important photographs. Television personality and bluegrass musician Doc Mercer and his wife, Julie, who reside in Kentucky in a house located on the Monroe family's homestead, and Jim Peva, a retired Indiana state trooper who became a close friend of Bill Monroe, provided several vintage photographs. Virginian Gary Reid's sharp eye helped immensely in the editing. Photographer Becky Johnson, who does a weekly bluegrass radio show with the Appalshop in Whitesburg, Kentucky, contributed several high-quality photographs. There is a special thanks extended to music collector Freeman Kitchens from Drake, Kentucky, both for his historical insights and for the help he offers so freely each time he is asked. Lastly, without the technical help of Fort Wright native Dr. Paul Tenkotte, as well as that of my wife, Sharon, and my nephew, Michael Claypool, this project could not have been completed.

# INTRODUCTION

Two things that naturally go hand in hand for bluegrass musicians are the abounding pride they have for their music and the high value they place upon their heritage. Core values such as patriotism, religion, love for the land, nostalgia for the past, and reverence for home and family are the themes oft repeated by the bluegrass musicians who perform the songs they and their audiences love.

What is it that makes bluegrass music so alive, so dynamic and so appealing? For certain, bluegrass is a uniquely American music genre, a musical format undeniably "born in the USA." There is controversy concerning the origins of bluegrass, a term that now defines a wide range of musical expression. Kentucky's Bill Monroe has been labeled "The Father of Bluegrass Music," but others say Earl Scruggs and Lester Flatt, two of the mainstays in Monroe's legendary mid-1940s bluegrass band, deserve much of the credit.

The argument concerning the origins of the term "bluegrass" revolves around the fact that in 1939, Monroe formed a band called Bill Monroe and the Blue Grass Boys (both to identify his heritage and to honor his home state of Kentucky). Later, in 1950, he put out a songbook, *Bill Monroe's Blue Grass Country Songs*, which was the first such publication to use the term "bluegrass" in its title. The counterclaim, as recounted by Earl Scruggs, centers upon the fact that Flatt and Scruggs left Bill Monroe's band in 1948 to form their own country music band. Soon, however, audiences were calling out to Flatt and Scruggs to "play some of those songs" they had recorded and performed when they were Blue Grass Boys. Somehow, this morphed into the audience yelling out for Flatt and Scruggs to "play us some more of that bluegrass music." Fittingly, bluegrass music, a music that is so much the music of the people, thus may very well have been named by the people themselves rather than by any of the musicians who were performing it.

What is certain, however, is that Bill Monroe and those who worked with him should be credited with defining, standardizing, and then preserving what can best be described as "classic bluegrass." The components of classic bluegrass are well known. It is music that is played by an acoustic ensemble consisting of five or six musicians playing standardized stringed instruments: a banjo, a fiddle, a mandolin, an upright bass, and one or two guitars, one of which is sometimes a resonator guitar, frequently called a dobro.

The lead singer, who is often a high tenor, is likely to be the only one singing all the words to the songs being performed, and he is joined in the choruses by various members of the band in order to add tight harmonies. The band's repertoire of songs stresses themes related to rural life, simpler times, memories of times gone by, and strong family values, with a flavoring of gospel songs thrown in for good measure. Good bluegrass musicians are the masters of split-second timing, and the tempo of bluegrass music is many times faster than country tempos, or as Library of Congress music scholar Alan Lomax would assert, bluegrass music was "folk music with overdrive." Whatever questions might linger about the origins of the term "bluegrass," there is one constant in this story—Bill Monroe's steadfast determination to preserve the stylized musical format he had helped to create.

William "Bill" Smith Monroe was born on September 13, 1911, in Ohio County, Kentucky. His family's farm was located on land known as Jerusalem Ridge, where today a nonprofit foundation oversees the restoration and preservation of the Monroe family's properties. An annual bluegrass festival is held at Jerusalem Ridge in the fall, and the profits help to fund the maintenance and improvement of the buildings that remain on the grounds. The Monroe family was hit hard by the Depression and the death of Bill's mother, Malissa, when he was only 10 years old. Bill was the youngest of eight children. His father, "Buck," had to scramble to keep afloat, so Bill was essentially raised by his siblings and by his mother's brother, Pendleton Vandiver (who was immortalized in Bill's 1950s song "Uncle Pen"). Vandiver was a talented musician who took Bill under his wing and showed young Bill the musical ropes.

Monroe's life story is well documented. Bill joined his siblings in 1929 in a town located outside of Chicago, Illinois, and he and other members of the family soon landed jobs singing on Chicago's radio station WLS, one of the 500,000-watt mega-stations broadcasting during the early years of radio. By 1934, Bill and his brother Charlie had struck out on their own, soon becoming country music and gospel recording stars in North Carolina. When the brothers parted ways in 1938, Bill continued in music as a solo artist.

Bill formed two country music bands, first in Arkansas and then in Georgia, and had only limited success. He then hired guitarist and vocalist Cleo Davis, who accompanied him to Asheville, North Carolina. There they were hired to perform on a daily radio music show. During this period, Bill began hiring the band that would become known as Bill Monroe and the Blue Grass Boys. By 1939, Monroe and his band were performing as regulars on the *Grand Ole Opry* in Nashville, Tennessee, and the rest is history. Monroe and the bands he formed were slowly refining what came to be referred to as the bluegrass style of music.

Bill added the phenomenal three-finger-style banjo player Earl Scruggs and talented guitarist Lester Flatt to his band in 1945, along with fiddler Chubby Wise and bassist and comedian Cedric Rainwater (Howard Watts), producing what many deem one of the best bluegrass bands ever assembled. When Flatt and Scruggs left Monroe to form their own band in 1948, an important subdivision of bluegrass music took place. Even before Flatt and Scruggs had departed from the Blue Grass Boys, the Stanley Brothers (1946–1966) were playing music clearly influenced by Monroe's stylings, and other performers from this era (such as Reno and Smiley, Jim and Jesse McReynolds, Jimmy Martin, and Mac Wiseman) would soon be playing some bluegrass songs during their country music shows as well. The audiences' reactions whenever these performers and their bands played bluegrass was so demonstrative that it was just a matter of time until some bands abandoned country music and new bluegrass bands were formed.

Although bluegrass performers were to have occasional hits such as "The Orange Blossom Special" (1941), "Blue Moon of Kentucky" (1946; made the official state bluegrass song of Kentucky in 1989), "Foggy Mountain Breakdown" (1949), and "Rocky Top" (1967; made Tennessee's official state song in 1982), country music still ruled both the airways and the recording studios. Changing musical tastes, including the advent of rock and roll in the late 1950s and early 1960s, along with the folk revival and the so-called British Invasion of that same era, seemed to relegate bluegrass music to the back burner.

The bluegrass bands of these times sometimes responded to the changing tastes in music by experimenting with new vocal harmonies, adding new band instruments such as the accordion, and even recording irreverent songs such as Kentuckian J. D. Crowe's controversial bluegrass hit "My Home Ain't in the Hall of Fame" (1978). Moreover, the Osborne Brothers from Hyden, Kentucky, one of the most commercial of the bluegrass bands of this era, made a concerted effort to appeal to mainstream country music listeners by adding drums and steel guitars to their recordings. Monroe often responded by shaking his head in disgust, blasting what he considered to be "the blasphemers of bluegrass," or by refusing to acknowledge the presence of the offending parties (including both Earl Scruggs and Lester Flatt) whenever Monroe encountered them. This was just posturing, since even Monroe had experimented with adding various new instruments, utilizing new harmonies, and carefully guarding the fact that there was a woman traveling along

with him and his band who sometimes played backup accordion in the shadows during the Monroe band's performances. Moreover, if one listens carefully, the sounds of an electronic organ can be heard in some of Monroe's recordings of the 1950s.

Monroe and the other bluegrass bands hung on, not because they expected to reap great financial gains as bluegrass performers, but because they loved the music and reveled in the opportunity to play it. One of the compelling things about bluegrass music is that it allows musicians to showcase their dexterity on stringed instruments while performing instrumental breaks. From opportunities such as these, legends were born. Kenny Baker from Jenkins, Kentucky, for instance, performed four different stints between 1957 and 1989 with Monroe's band and was dubbed by Monroe "the greatest fiddler in bluegrass music." Earl Scruggs, while performing with Monroe, established his reputation as the greatest three-finger-style banjo player ever, and Lester Flatt won high acclaim for his famous breakaway "G-chord run" on the guitar. Then there is Ricky Skaggs from Cordell, Kentucky, who began playing the mandolin at age five and stepped from the audience to play with Monroe at a performance at Martha, Kentucky, while Skaggs was only six years old. Today Skaggs (shown performing with Monroe on this book's cover) is not only recognized as one of the finest mandolin players in the world, but his world-class band, Kentucky Thunder, features band members who are perennial award winners as bluegrass performers.

The late 1950s, the 1960s, and the 1970 were important transitional years for bluegrass music, as some bluegrass bands continued to trod traditional roads while other groups headed bluegrass music down innovative and bold new pathways. By the mid-1950s and early 1960s, bluegrass music had become a niche genre catering to a small but dedicated fan base that continued to support this down-home style of music. Monroe and his Blue Grass Boys remained a staple on the *Grand Ole Opry*'s live performance stage with the band's membership changing about as often as the weather. Meanwhile, other Kentuckians such as the Coon Creek Girls, Bobby and Sonny Osborne, John and Rollin Sullivan (Lorenzo and Oscar), Tom T. Hall, Merle Travis, Grandpa Jones, and Martha Carson made a living performing bluegrass music blended with country or gospel music, occasionally producing classic country/bluegrass hits like the Osborne Brothers' chart buster "Rocky Top," Travis and Jones's rendition of "Eight More Miles to Louisville," and Carson's gospel classic "Satisfied."

Simultaneously, two seminal events helped to move interest in bluegrass music from its Appalachian base and set the stage for the growth and revitalization of bluegrass music: an article in *Esquire* magazine in 1959 by Alan Lomax defining bluegrass music as one of the styles that transformed "the roots of American music" and, secondly, the advent and fast-spreading popularity of commercial bluegrass festivals. The most famous bluegrass festival, which remains the longest continuously held one, is the festival Bill Monroe established at Bean Blossom, Indiana, in 1967. Today a countless number of bluegrass festivals are held worldwide, and major bluegrass festivals are conducted annually in every region of Kentucky.

Meanwhile, the steadfast and narrow performance format established by Bill Monroe and other first-generation bluegrass musicians like him was being subdivided by a new generation of bluegrass musicians into something called progressive bluegrass or "newgrass."

The latter term is attributed to Ebo Walker, a member of Sam Bush's Kentucky-based progressive bluegrass band, New Grass Revival. Associated with this change was the fact that bluegrass music was beginning to spread from it base in Appalachia to new urban audiences and other new settings nationwide, and several highly talented younger musicians had begun to perform it.

The changes that were introduced by the newgrassers into bluegrass music were dramatic. New chords were added to bluegrass music's sonic palette, songs with elements of jazz, country, folk, and rock music were imported, and new electric instruments, drums, piano, and more, were used to ramp up performances. The young Turks of newgrass music had decided to offer a direct and deliberate alternative to what they saw as the somber, serious, intense, and sometimes pompous classic type of bluegrass music played by Bill Monroe, Carter and Ralph Stanley, and Del McCoury.

Monroe had changed the way things were done on the *Opry* in 1939 when he and his band took the stage wearing jackets, ties, and smart Stetson hats instead of the traditional rough-and-ready hillbilly clothes worn by the other performers. Now the tables were being turned on Monroe and his peers. As one music critic observed, "The new hybrid bluegrass bands featured flashy, experimental music, large doses of humor in the choice of songs, between-song comments, often raucous stage antics, and generally an irreverent look at the traditional strictures of both the music and even life itself." It was exciting and drew many new fans to bluegrass, but for Monroe and the other performers of classic bluegrass music it was a heretical split that remains an ongoing source of contention. So far, there has been room in bluegrass music for both.

# One

# THE BEGINNINGS

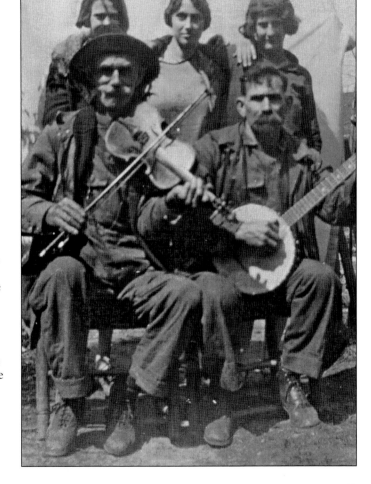

This undated photograph is the most well-known image of fiddle player Pendleton "Pen" Vandiver, Bill Monroe's uncle; the other musician is Clarence Wilson, and the women are unidentified. Monroe immortalized Vandiver in the classic bluegrass song "Uncle Pen." Monroe began living with his uncle Pen in 1927, following his father's death, and always credited Vandiver for teaching him to play mandolin. (Courtesy of Doc and Julie Mercer.)

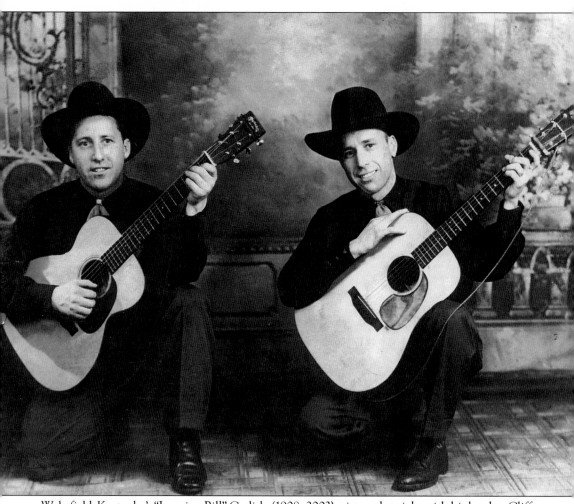

Wakefield, Kentucky's "Jumping Bill" Carlisle (1908–2003), pictured at right with his brother Cliff, performed professionally for over 70 years. Carlisle was a singer, songwriter, comedian, and guitarist. His comical antics on stage and his precision and speed on the guitar were components that helped link him to the evolution of bluegrass musical performance. (Courtesy of Berea College.)

Cliff Carlisle (far left), Bill Carlisle's older brother, was born in Taylorsville, Kentucky. Cliff, who mastered yodeling and pioneered the steel guitar, began performing in 1919 at age 16. He continued performing until the 1960s. Yodeling was frequently used in early bluegrass ensembles, and the steel guitar (dobro) is one of the standard instruments in many bluegrass bands. (Courtesy of Berea College.)

This is a 1935 photograph of the stringed-instrument band the Cumberland Ridge Runners, founded by Kentuckian John Lair. This band is typical of the several hundred such string bands that played country and up-tempo instrumental songs during the pre–World War II era. Songs like the ones this band played foreshadowed the kind of music played later by bluegrass musicians. (Courtesy of Berea College.)

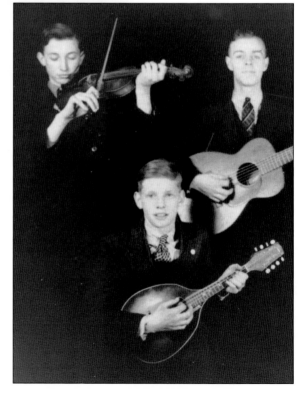

Sleepy Jim's String Band (Jim Hammons, fiddle, Sam Hammons, mandolin, and Chester Howard, guitar) from Covington, Kentucky, was a typical 1930s country music string band; bands like this foreshadowed the five- and six-man stringed-instrument bands formed during the 1940s and 1950s to play bluegrass music. (Courtesy of Mike Hammons.)

John Lair, shown here, founded the Renfro Valley Barn Dance Show. Lair quit his job with Chicago radio station WLS during the 1930s to return to his home in Rockcastle County, Kentucky, in order to pursue his dream of promoting live musical performances. Several important musical careers were launched on the Renfro Valley Barn's stage, and bluegrass music has remained a Renfro Valley programming staple. (Courtesy of Renfro Valley.)

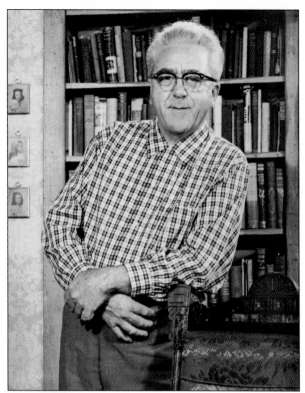

Red Foley, from Berea, Kentucky, was one of America's most famous country and gospel singers. Red was a member of John Lair's Cumberland Ridge Runners during the 1930s and in 1937 joined Lair in the founding of Renfro Valley. A skilled guitarist, Foley was best known for his singing of gospel songs, which later became an important part of many bluegrass performances. (Courtesy of Renfro Valley.)

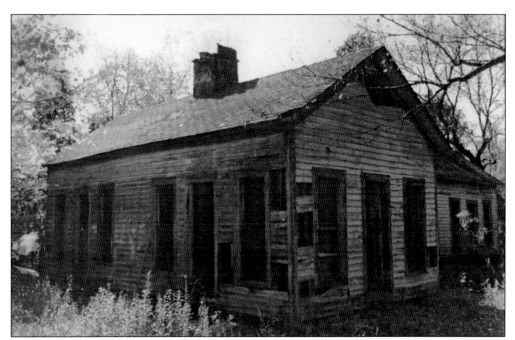

This is an image of what remained of the house the musical Monroe children grew up in before the deaths of their mother, Malissa, in 1921 and their father, "Buck," in 1927. The house is located near the town of Rosine in Ohio County, Kentucky, on land known as Jerusalem Ridge. (Courtesy of Doc and Julie Mercer.)

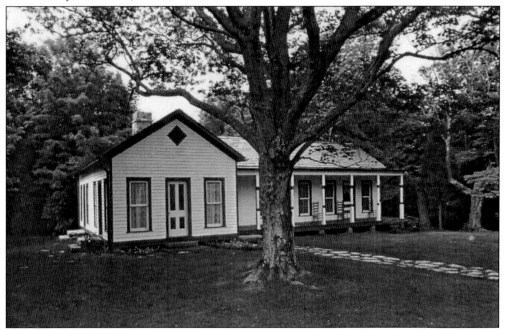

This is a picture of the restored Monroe family home place on Jerusalem Ridge. The site is overseen by a nonprofit foundation. The property's overseers, Doc and Julie Mercer, live in a house nearby and supervise tours of the various Monroe family properties. A popular annual bluegrass festival is held on the grounds. (Courtesy of Doc and Julie Mercer.)

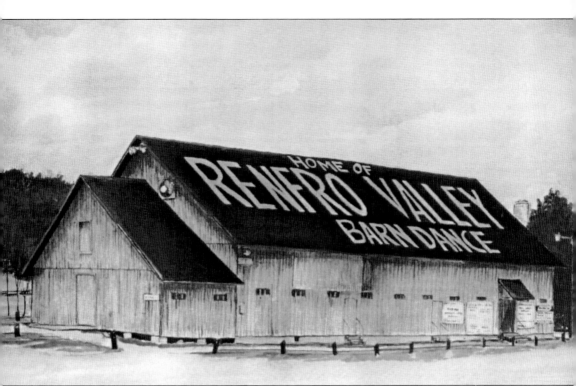

This image is taken from an original watercolor painting by noted Kentucky artist Mark McFerron. Mark grew up in Rockcastle County, Kentucky, where the Renfro Valley Barn is located. McFerron began drawing at age four and specializes in portraying historic themes in his artwork. His wife, Leslie, graduated from a performing arts school in Louisville and has been featured singing on gospel albums, gospel songs being an important component of most bluegrass musical performances. (Courtesy of Mark McFerron.)

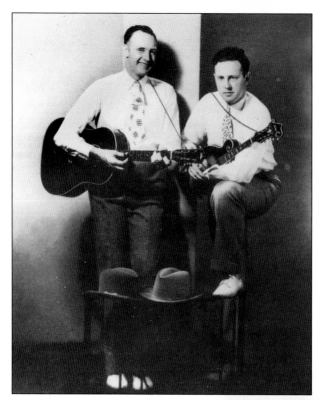

In this 1936 picture, the popular country music singing duo Charlie (left) and Bill Monroe are seen while they were performing together in the Carolinas. Bill and Charlie recorded 60 songs between 1936 and 1938 and were one of the most popular brother singing duos in America. However, they split up in 1938, when Bill left to pursue his own separate singing career. (Courtesy of the Southern Folklife Collection.)

Vocalist and banjo player Roscoe Holcomb was born in 1911 in Daisy, Kentucky. He was discovered by folklorist John Cohen in 1959 and was persuaded to leave his work as a farmer and coal miner to become a professional musician. Roscoe was a regular at folk festivals during the 1960s and 1970s, appearing with Ralph Stanley's bluegrass band and others. (Courtesy of Berea College.)

*Two*

# THE 1940S AND EARLY 1950S

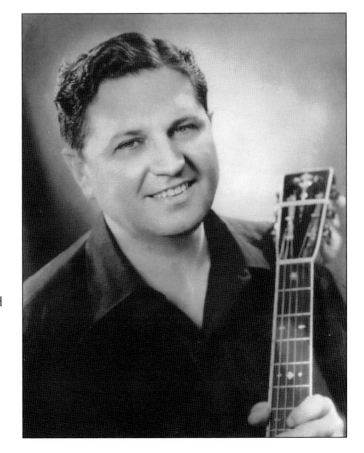

Bradley Kinkaid, who became one the most popular performers on early radio, was born in 1895 in Garrard County, Kentucky. Kinkaid had a high tenor voice reminiscent of the lead tenor voices so common in bluegrass music. His popular mail-order songbooks taught a generation of country and bluegrass musicians many of the songs they would later perform. (Courtesy of the Southern Folklife Collection.)

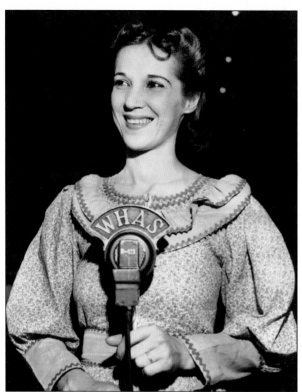

Lily May Ledford, from Powell County, Kentucky, is shown performing on Louisville radio station WHAS in 1941. Ledford was the lead singer of the Renfro Valley's band the Coon Creek Girls, which performed before the king and queen of England at the White House in June 1939. (Author's collection.)

Black-eyed Susan Ledford (left), Lily May Ledford (center), and Rosie Ledford (right) were three of the original Coon Creek Girls. Created by John Lair and part of the Renfro Valley Barn Dance Show, the Coon Creek Girls were said to have been the first all-girl string band on radio. They are the namesake of the retired contemporary bluegrass band the New Coon Creek Girls. (Author's collection.)

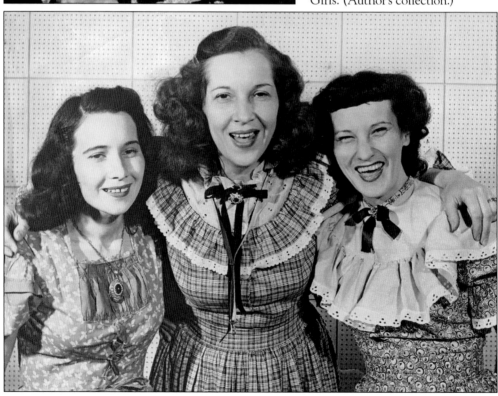

Dubbed "the first hillbilly to own a Cadillac," Cynthia Mae "Cousin Emmy" Carver, pictured in the second row with bows in her hair, was a Kentucky mountain girl singer who hit it big in country music during the 1940s. She was also popular during the folk era of the 1950s and 1960s, and her successful career foreshadowed the current popularity of female country singers on the bluegrass circuit. (Courtesy of the Southern Folklife Collection.)

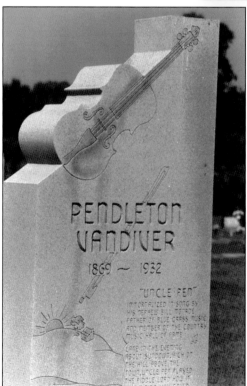

This is the memorial monument to Pendleton Vandiver (1869–1932), who was the brother of Bill Monroe's mother, Malissa. It is located in the city cemetery in Rosine, Kentucky, and has become a popular visitation site for bluegrass music fans, especially after Bill Monroe wrote and recorded the song "Uncle Pen" as a tribute to his favorite uncle. (Photograph by Becky Johnson.)

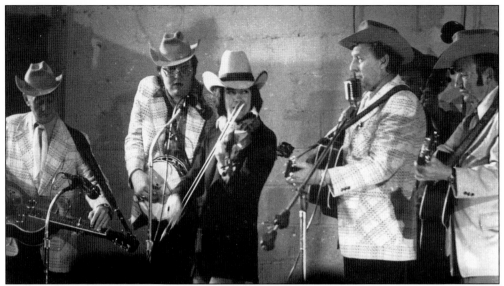

Lester Flatt (far right), a guitar player famed for his G-chord breaks, joined Bill Monroe's Blue Grass Boys in 1945. Along with banjo player Earl Scruggs, Flatt is remembered as a key member in a band many considered not only Monroe's best but also one of the greatest bluegrass ensembles ever assembled. Flatt and Scruggs left Monroe in 1948 to form their own band, Flatt and Scruggs, which lasted until 1969. (Courtesy of Berea College.)

Considered the best three-finger-style banjo player of all time, bluegrass musician Earl Scruggs joined Bill Monroe and the Blue Grass Boys in 1945. Scruggs and Lester Flatt left Monroe in 1948 to form their own band, Lester Flatt and Earl Scruggs and the Foggy Mountain Boys. Flatt and Scruggs parted company in 1969, after which Scruggs formed a new country-rock band with his three sons. (Photograph by Becky Johnson.)

Comedian, banjo player, and onetime Blue Grass Boy David "Stringbean" Akeman was born in 1918 in Annville, Kentucky. Bill Monroe hired Akeman to play banjo (which he did not do very well), to be funny (which he was), and to play first base on Monroe's traveling baseball squad. After leaving Monroe, Akeman became a regular on the *Grand Ole Opry*. He was murdered by burglars in 1973. (Courtesy of Phillip Akemon.)

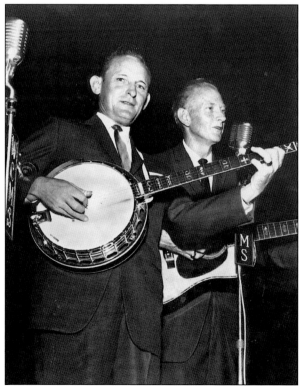

Don Reno (left) was a three-finger-style banjo player like Earl Scruggs. Bill Monroe offered Reno a job in the mid-1940s, but Reno turned it down to enter military service, so Monroe hired Scruggs instead. In 1949, Reno replaced Scruggs in the Blue Grass Boys, but he left to form the Tennessee Cut-Ups. In the 1950s and 1960s, he teamed with Red Smiley in that band. (Courtesy of Berea College.)

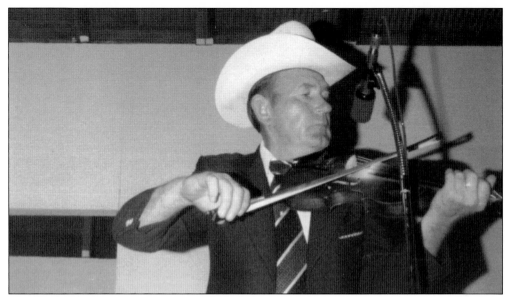

Kenny Baker, a fiddle player from Jenkins, Kentucky, played with Bill Monroe and the Blue Grass Boys on four different occasions between 1957 and 1989. Labeled by Monroe as the greatest fiddler in bluegrass music, Baker would cut a number of solo albums that are highly valued by collectors today. Baker was inducted into the International Bluegrass Music Association (IBMA) Hall of Honor in 1999. (Courtesy of Jim Peva.)

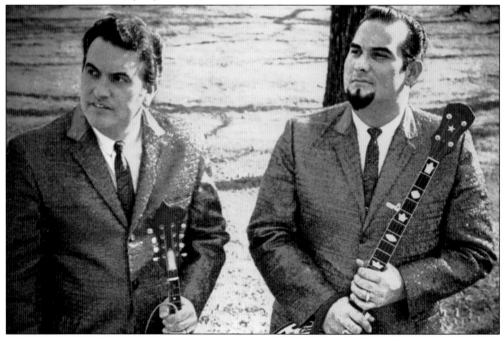

Roland "Sonny" Osborne (right), from Hyden, Kentucky, is pictured in the 1950s with his brother Bobby. Sonny began his career in 1939 with the Lonesome Pine Fiddlers and in 1951 played for a few months with Bill Monroe's Blue Grass Boys. Next Sonny and his brother Bobby formed the Osborne Brothers bluegrass duo, which became one of the most successful bluegrass acts ever assembled. (Courtesy of Gene Thompson.)

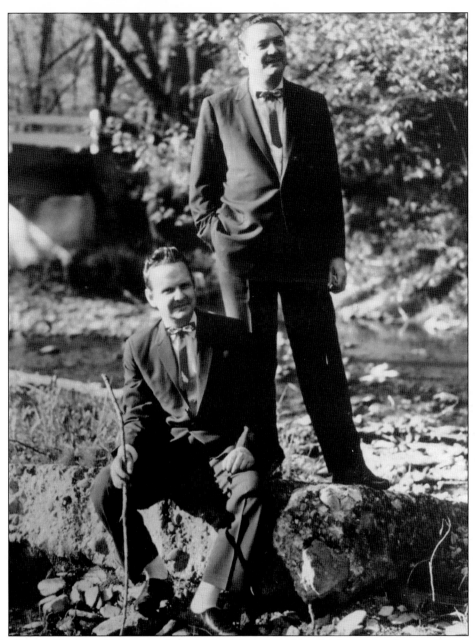

The Stanley Brothers, Carter (standing) and Ralph, are considered to be among the most important of the first generation of bluegrass musicians. They began as "hillbilly musicians" during the 1940s, but by the last part of that decade, their band was playing bluegrass music patterned after the music of Bill Monroe's band. Carter performed briefly in 1951 with Bill Monroe and the Blue Grass Boys after he and his brother had stopped singing together. Carter, who wrote hundreds of songs and played guitar, was considered one of the era's finest natural singers. The Stanley Brothers reunited in 1953 and signed a contract to record with Mercury Records. In 1958, Mercury moved the Stanley Brothers to its Starday label; later they recorded for Wango and King Records. The Stanley Brothers continued to perform together until Carter's death from liver cancer in 1966. (Courtesy of Vernon McIntyre.)

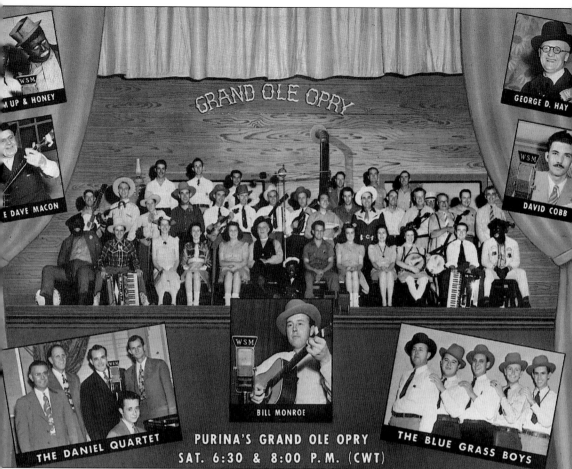

The *Grand Ole Opry*, which first performed in Nashville's Ryman Auditorium, was the stage where Bill Monroe defined and perfected the musical style that has come to be known as bluegrass. Monroe, who would become known as "the Father of Bluegrass Music," was hired to play with the *Opry* in 1939 by the show's manager, George Hay, after auditioning for the job. Monroe continued to play the *Opry* for 50 years. Hay had remarked upon hiring Monroe that the only way Bill would lose the job would be if he quit. Dressed in style-setting suits and wearing Stetson hats and string ties, Monroe and his Blue Grass Boys broke the tradition of *Opry* performers wearing country-style outfits. In this undated publicity advertisement, Monroe is singled out and featured at the bottom and is pictured with his band at bottom right. (Author's collection.)

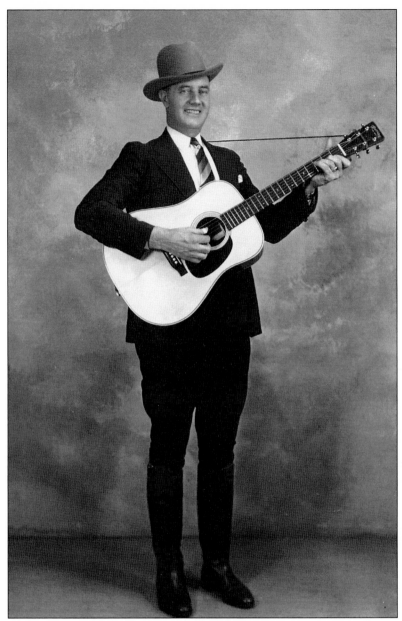

Singer and guitar player Charlie Monroe, one of Bill's older brothers, was born on July 4, 1903, on his family's farm near Rosine, Kentucky. A sister, Bertha, also played guitar and sang, and another brother, Birch, played fiddle and sang. When it came time for Bill, the youngest Monroe child, to choose his stringed instrument, all that was left was the mandolin, which he later mastered with the help of his uncle Pendleton Vandiver. The musical Monroes performed on radio stations in Illinois and Indiana during the 1930s. Charlie and Bill struck out together and performed as the Monroe Brothers in North Carolina from 1934 until 1938, when Bill left, chafing at Charlie's role as lead singer. Charlie then formed the Kentucky Pardners and had a successful recording career with both Decca and RCA Records during the 1950s. After 15 years of retirement, Charlie played for three years on the music festival circuit in the 1970s before his death in 1975. (Courtesy of the Southern Folklife Collection.)

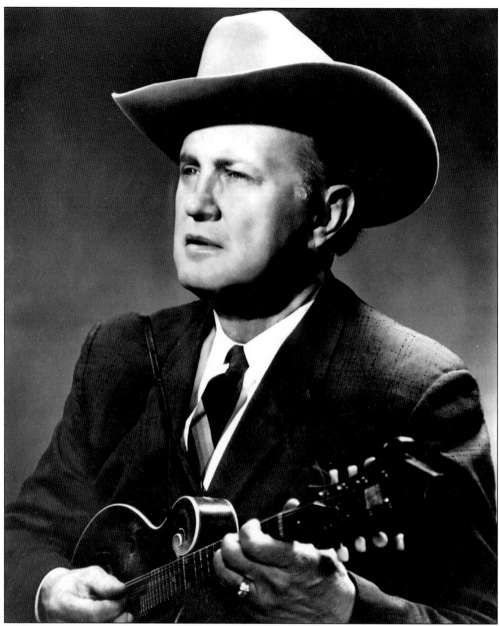

William Smith "Bill" Monroe, "the Father of Bluegrass," was born on September 13, 1911, on his family's farm just outside of Rosine, Kentucky. The youngest of eight children, Bill was shy, cross-eyed, and near-sighted. After his father's death in 1927, Bill lived with his uncle Pendleton Vandiver, and it was under his uncle's tutelage that Bill mastered tenor singing and mandolin playing. Bill joined his siblings in Indiana in 1929 and later performed on radio with them during the 1930s. He and his brother Charlie left for North Carolina in 1934 to become the Monroe Brothers. In 1938, Bill left Charlie to form his own band, the Kentuckians. Later that year, he was back in North Carolina, where he would assemble the band he called Bill Monroe and the Blue Grass Boys. This was the beginning of a career that made Bill and the various versions of this band famous. (Courtesy of Berea College.)

# *Three*

# THE BLUEGRASS REVIVAL'S FORMATIVE YEARS

Country and bluegrass banjo player David "Stringbean" Akeman is shown out of costume with his wife, Estelle. When performing, Akeman wore clothing that accentuated his height. He worked with Bill Monroe's band during the 1940s before joining the *Opry* during the 1950s and later worked on the television show Hee Haw (1969–1973). He and his wife were murdered at their home by robbers in 1973. (Courtesy of Phillip Akemon.)

Merle Travis (standing in the cowboy hat) is shown visiting his hometown in Kentucky in this 1947 photograph. Travis, who wrote "Sixteen Tons" and several other hit songs, was inducted into the Nashville Songwriters Hall of Fame in 1970 and the Country Music Hall of Fame in 1977. "Travis picking," a syncopated style of guitar thumb picking, is sometimes performed at bluegrass shows by Kentucky-based bluegrass musicians. (Courtesy of the Greenville, Kentucky, Library.)

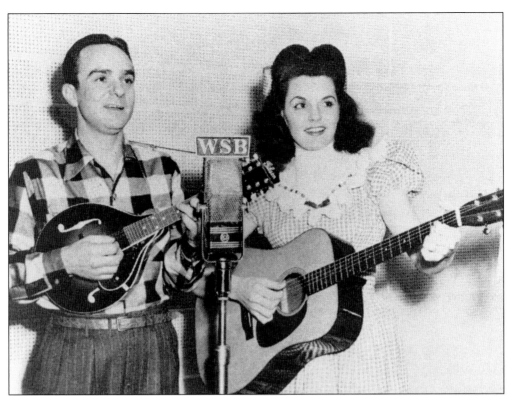

James Carson, of Richmond, Kentucky, and his wife, Martha, of Neon, Kentucky, made up the Barn Dance Sweethearts, one of the Renfro Valley Barn Dance's most popular husband-and-wife singing acts during the 1940s and early 1950s. Martha (Irene Amburgey) had two sisters who also sang at Renfro Valley. The Carsons used close vocal harmonies, a style of singing that is fundamental to bluegrass music. (Courtesy of Berea College.)

Richard Burnett, a blind banjo-playing troubadour from Monticello, Kentucky, began performing with fellow Kentuckian Leonard Rutherford in 1914 as Burnett and Rutherford. Burnett's 1913 ballad "Farewell Song" evolved into the "Man of Constant Sorrow," featured in the 2000 hit film *O Brother, Where Art Thou?* The movie's rendition of this bluegrass standard helped to spark a wave of interest in bluegrass music. (Courtesy of Harlan Ogle.)

Country, folk, and gospel-bluegrass legend Molly O'Day (born LaVerne Williamson) was from Pike County, Kentucky. O'Day was a talented singer and skillful banjo player; Earl Scruggs once recalled that he had lost a banjo picking contest to her in Louisville, Kentucky. Later, O'Day, an ordained minister, hosted and performed on a West Virginia gospel radio show that featured several bluegrass performers as guests. (Courtesy of *Bluegrass Unlimited*.)

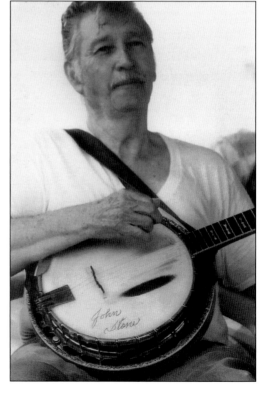

Old-time-style banjo player John Slone was from Williamstown, Kentucky. Slone began performing in country bands during the 1940s and later performed regularly in bluegrass bands based in central and northern Kentucky. He was also a respected teacher who taught for many years in Burlington. (Courtesy of Eddie Chipman.)

The Cumberland Valley Boys, a Renfro Valley–based group of country and bluegrass stringed instrument musicians, were the backup band for Red Foley. Foley recorded seven top hits with this group between 1947 and 1949, including a number-one song, "New Pretty Blonde (New Jolie Blonde)." (Courtesy of Berea College.)

Bluegrass music pioneer Red Spurlock grew up just outside of Buckhorn, Kentucky. Here he poses with his boyhood banjo, which his father carved by hand before moving to southern Ohio to work. This instrument's neck was hewn from maple and attached to a coffee can. Spurlock played bluegrass with Sonny Osborne, Red Allen, and Frank Wakefield and later headed the Red Spurlock Band. (Courtesy of Vernon McIntyre.)

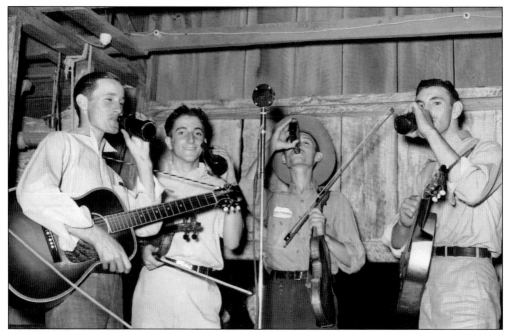

This picture of a bluegrass band from Kentucky calling itself the Bushwackers dates to the mid-1950s. Two of the band members lived in Fort Wright, Kentucky. The picture captures what it was like to perform in the early days of bluegrass music, when some bands would drink beer and/or whiskey on stage while taking a break from playing. (Courtesy of Vernon McIntyre.)

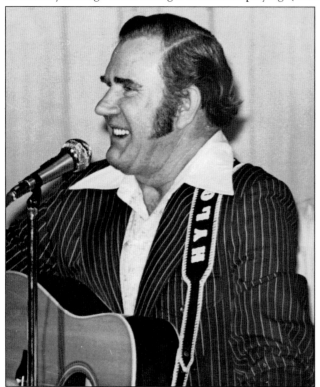

Frank "Hylo" Brown, from River, Kentucky, was a Capitol recording artist from 1954 to 1961. Brown, who was a regular on the radio broadcast of *WWVA Jamboree* out of Wheeling, West Virginia, got the nickname "Hylo" (high low) for his ability to switch his singing voice from a baritone to a falsetto, one octave higher. (Courtesy of *Bluegrass Unlimited*.)

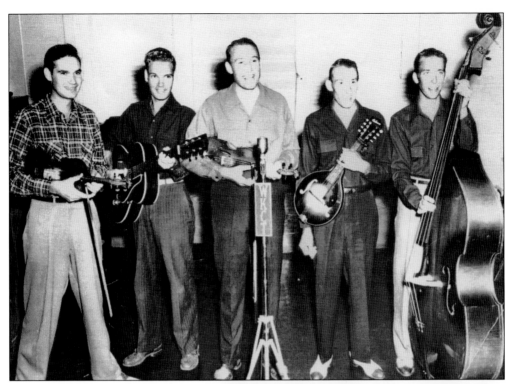

This 1950s bluegrass band, Joe Marshall and the Roving Ramblers, was based in Bowling Green, Kentucky. In its heyday, it was one of the most popular bands playing Kentucky's early bluegrass music circuit. Pictured here are, from left to right, Gene Kitchens, Porter Kitchens, Joe Marshall, Kenny Marshall, and Percy Chaffin. (Courtesy of Freeman Kitchens.)

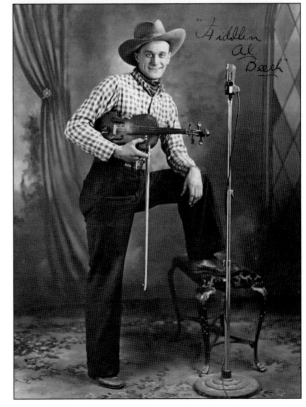

"Fiddlin' Al" Beech was a Kentucky-born old-time-style fiddle player who played bluegrass music during the 1940s and 1950s. Beech was just one of the many old-time fiddle players drawn to bluegrass music because it allowed them to showcase their skills during the instrumental breaks that commonly occur in the genre. Beech would best be described as a bluegrass band sideman. (Courtesy of Vernon McIntyre.)

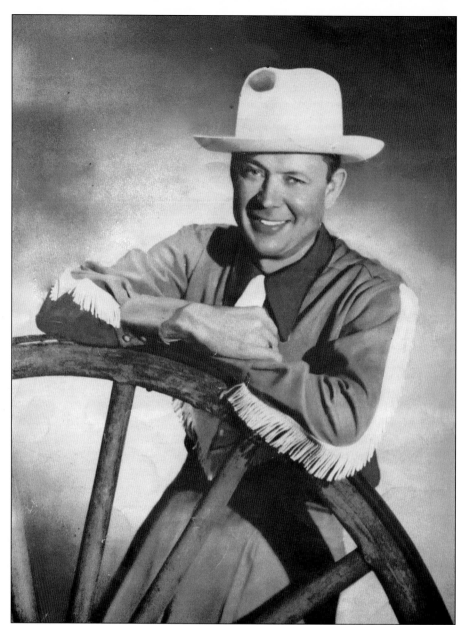

Country singer, songwriter, disc jockey, label owner, and record salesman Jimmie Skinner was born on a farm near Berea, Kentucky, on April 29, 1909, and later resided in both Ohio and Tennessee. While living in Knoxville during the 1950s, Skinner began writing songs for bluegrass entertainers. Jimmy Martin, for example, had a bluegrass hit with Skinner's song "You Don't Know My Mind" in the 1950s. Skinner also recorded two songs for Mercury Records, one of the seven record labels for which he would record. When things dried up for Skinner, he moved to Cincinnati, started his own Vetco music label, and opened a music store called the Jimmie Skinner Music Center. Skinner's successful music store focused on selling country and gospel music (some of which was performed by bluegrass bands). After Skinner's death, bluegrass musician Vernon McIntyre purchased and operated the store, but McIntyre would later relocate the business to Wapakoneta, Ohio. (Courtesy of Vernon McIntyre.)

Nicholasville, Kentucky's J. D. Crowe, pictured here, is one of the true legends of bluegrass music. Crowe began his career in 1955 as a member of Mac Wiseman's band. In 1956, he became the banjo player in Jimmy Martin's band, where he earned fame as one of the world's greatest banjo players. Crowe would later form his own bands in the 1960s and 1970s. (Courtesy of Mike Morbeck.)

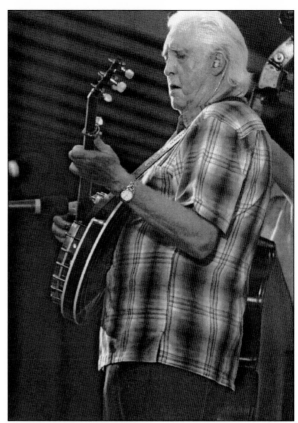

These three Kentuckians, Sherman Skidmore (fiddle), Albert Neal (guitar), and Jimmy Skidmore (banjo), were part of a bluegrass ensemble from the 1950s. The Skidmore brothers were two of the original Cumberland Gap Boys, a well-known 1930s stringed-instrument band. Jimmy Skidmore, a resident of Clay City, is retired and has impaired hearing. (Courtesy of Eddie Chipman.)

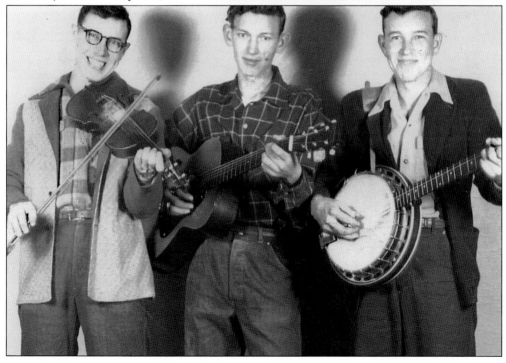

This is yet another old-time-style fiddler from Kentucky, called "Red Jim," who performed country and bluegrass music between 1930 and 1950. Red Jim was from Louisville, and although he never used his last name while performing, another musician who played shows with him recalled it as being either Overton or Overstreet. (Courtesy of Vernon McIntyre.)

Shown in this 1950s picture are eastern Kentuckians Coy Farmer (right) on guitar and Shorty Whitaker on mandolin. The third musician is unidentified. Whitaker is recalled by a number of bluegrass musicians as one of the finest mandolin players of this era. (Courtesy of Vernon McIntyre.)

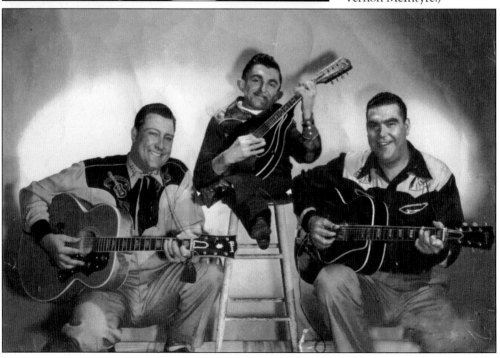

Legendary country and bluegrass banjo player and singer Louis Marshall "Grandpa" Jones was born on October 20, 1913, in Niagara, Kentucky. Jones earned the nickname Grandpa performing as Kentuckian Bradley Kinkaid's warm-up man during a show in Boston. Jones, who was often late coming on stage, was admonished by Kinkaid, who remarked "Hurry up and get out here, Grandpa," after seeing Jones standing in the wings. Before embarking as a professional musician, Jones held a variety of jobs, including work as a tobacco farmer, a carpenter, and a factory dismantler of old refrigerators. By the 1950s, Jones had become a fixture on the *Grand Ole Opry* and also worked at radio stations all across America. The clowning in his role as Grandpa sometimes disguised the fact that Jones was a highly skilled banjo player and talented singer. His recording of "Eight More Miles to Louisville" has become a bluegrass classic. (Author's collection.)

Ralph Baker and Southern Breeze was an ensemble of six Kentuckians who performed country and then bluegrass music from the 1940s into the 1980s. Pictured here are, from left to right, Tommy Taylor (fiddle), Eddie Chipman (electric bass), Ralph Baker (banjo), Willie Baker (harmonica), Bill Campbell (guitar), and Mike Carr (mandolin). (Courtesy of Eddie Chipman.)

This is the bluegrass singing duo Earl Taylor (left) and Jim McCall. In 1958, Taylor, a Virginian, formed the band Earl Taylor and the Stoney Mountain Boys. A year later, Taylor's band would become the first to perform bluegrass music at Carnegie Hall. Bill Monroe had been invited to perform there by folk music archivist and ethnomusicologist Alan Lomax, but Monroe believed Lomax was a communist and refused his offer. (Courtesy of Vernon McIntyre.)

The two bluegrass gospel singers featured in this picture are Jerry Sullivan and his wife Tammy, who is a Kentuckian. Jerry is related to the performers in the well-known gospel group the Sullivans. (Courtesy of Vernon McIntyre.)

The Coon Creek Girls certainly seem to be having fun wading in a Kentucky creek in this undated photograph. John Lair, the group's founder, insisted that each of these performers must use the name of a mountain flower as a part of their stage names. From left to right are Minnie "Black-eyed Susan" Ledford, Charlotte "Rosie" Ledford, Ester "Violet" Koehler, and May "Lily" Ledford. (Courtesy of Berea College.)

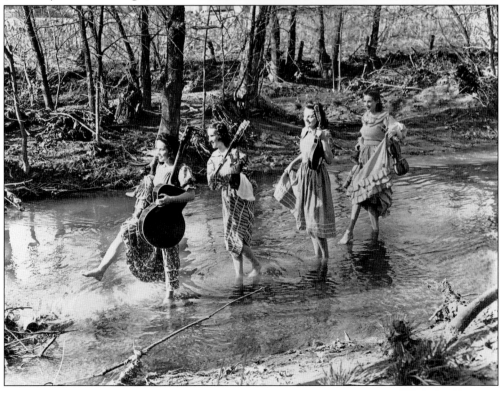

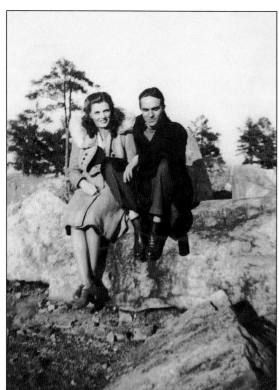

Sometimes there is time for musicians to have fun and just relax, as this picture of James and Martha Carson, taken during the late 1940s atop Lookout Mountain in Tennessee, illustrates. Unfortunately, the couple would divorce soon thereafter. Martha became a country music singing star on the *Opry* during the 1950s, and James continued performing at Renfro Valley into the 1970s. (Courtesy of Berea College.)

Songwriter and accordion player Frank "Pee Wee" King (with the accordion) lived in Louisville during the 1940s and coauthored several hit songs, including "Bonaparte's Retreat," "Slow Poke," and "The Tennessee Waltz." King originally wanted to name his waltz tune "The Kentucky Waltz," but there had already been a famous bluegrass song of that title written and recorded by Bill Monroe. (Courtesy of Berea College.)

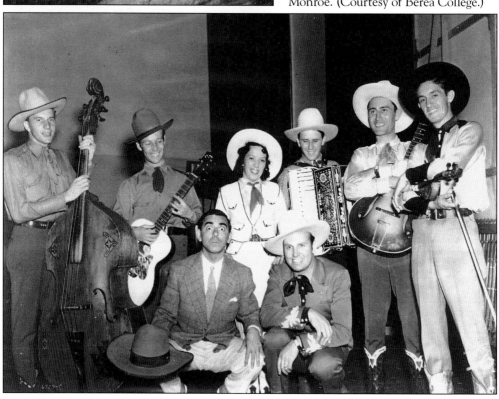

*Four*

# KEEPING THE FAITH

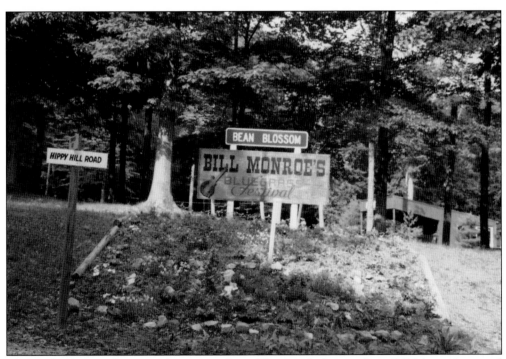

This is the famous flower garden sign at Bean Blossom, Indiana, where Bill Monroe's annual bluegrass festival has been held since June 1967. It is the longest continuously held bluegrass festival in the world. Monroe purchased these festival grounds in 1951. His 1967 festival was a two-day event, which Monroe dubbed "A Bluegrass Celebration." Even after Monroe's death in 1996, the festival grew and prospered. (Courtesy of Jim Peva.)

Kentucky-born Birch Monroe, one of Bill Monroe's older brothers, helped manage the annual bluegrass festival Bill put on at Bean Blossom, Indiana. During the 1960s, Birch performed at Bean Blossom in a gospel quartet that included his brother Bill, Roger Smith, and Jimmy Maynard. (Courtesy of Jim Peva.)

Pictured onstage at the Brown County Jamboree in Indiana in 1963 are Bill Monroe and his Blue Grass Boys. Bill's daughter Melissa was a special guest. Pictured from left to right are Bessie Lee Mauldin, Bill Monroe, Melissa Monroe, Joe Stuart, Bill "Brad" Keith, and Del McCoury. (Courtesy of Jim Peva.)

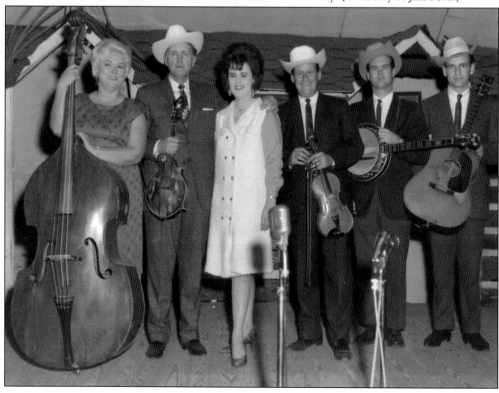

This is one of the mandolins that Bill Monroe used during his many performances with his Blue Grass Boys. After Monroe died in 1996, another of his mandolins was passed on to his son, James. James opened a museum honoring his father in Franklin, Kentucky, near an interstate exit leading south to Nashville, Tennessee. (Photograph by Becky Johnson.)

This was the favorite guitar of Bill Monroe's older brother Charlie Monroe (1903–1975). This guitar can been seen when it is put on display at the Monroe family's properties at Jerusalem Ridge in Kentucky. A foundation oversees these properties, the festival held there each year, and the items on public display. (Courtesy of Doc and Julie Mercer.)

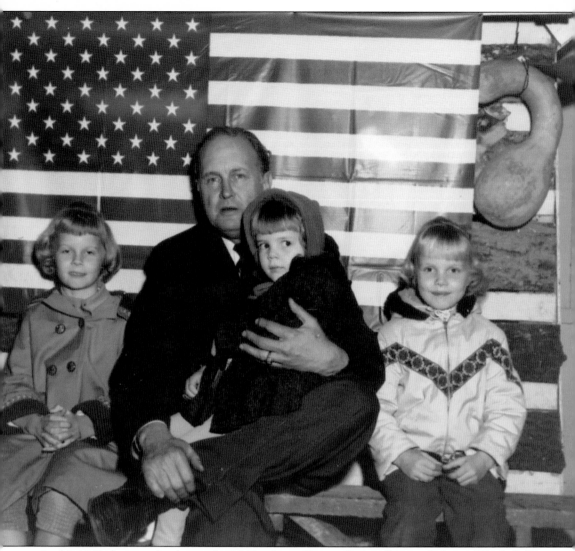

In this 1962 photograph taken at the Old Jamboree Barn in Brown County, Indiana, "Uncle Bill" Monroe is shown holding three-year-old Cathy Peva. To the left is Mary Peva, age eight, and to the right is Becky Peva, age seven. The father of these three girls, Jim Peva, is a retired colonel with the Indiana State Police who met and became friends with Monroe in 1961 while trying to book Monroe to do a bluegrass show. Peva and his wife attended Monroe's inaugural festival at Bean Blossom in 1967 and have attended every one since. One of Monroe's famous white Stetson hats, autographed by him, is displayed on a table in the Peva home. In May 2006, Peva published the book *Bean Blossom, Its People, and Its Music,* which is sold as a history and souvenir of the festival. (Courtesy of Jim Peva.)

Onetime Kentucky resident Mack Magaha, shown in this photograph from the late 1960s, had a long and distinguished career as a bluegrass songwriter and fiddle player. During the 1970s, he played fiddle in Reno and Smiley's bluegrass band, and he later worked on the *Opry*. Mack cowrote one of bluegrass music's classic hits, "I Know You're Married, but I Love You Still." (Courtesy of Vernon McIntyre.)

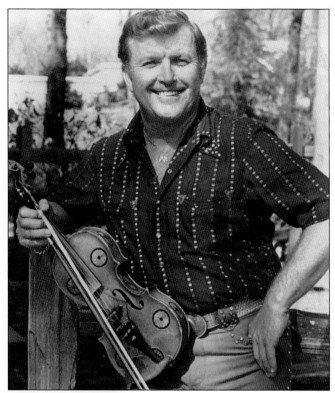

Kentuckians Karl Davis (left) and Harty Taylor are shown performing at the Renfro Valley Barn Dance Show. These two songwriters and musicians played both country and bluegrass music. Their most famous song, "Kentucky," has been recorded by country and bluegrass musicians alike. At one point, it almost became the state song of Kentucky, but Stephen Foster's "My Old Kentucky Home" prevailed. (Courtesy of Berea College.)

Bluegrass banjo player Henry Clay Sizemore is shown here with guitarist Michael E. Romanczuk in an August 1956 photograph. This picture was taken at Arlington Hall Station, Headquarters Platoon, in Arlington, Virginia. After being discharged from military service, Sizemore worked as a professional bluegrass musician. (Courtesy of Henry Sizemore.)

This is a photograph of Henry Clay Sizemore and his son, Charlie, a second-generation bluegrass musician; both men are from Magoffin County, Kentucky. The elder Sizemore, who is retired, headed the Hal Mountain Boys, one of the most popular Kentucky-based bluegrass bands of the 1950s and 1960s. Young Charlie Sizemore played in his father's band and now heads his own bluegrass band. (Courtesy of Henry Clay Sizemore.)

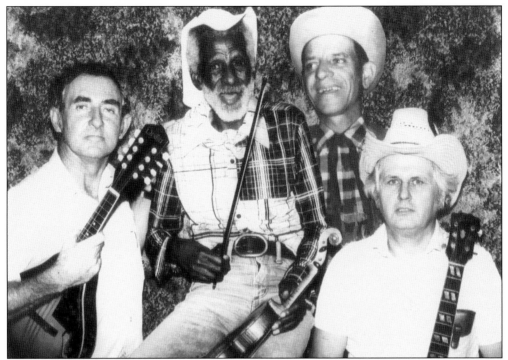

Comedic effect was often an integral part of bluegrass musical performances, as demonstrated by this picture of the band Bill Livers and the Holbrook Idiots. This group performed during the 1960s and was based out of Grant County, Kentucky. From left to right are Landis Webb, Bill Livers, Russell "Cannonball" Morrison, and Eddie Chipman. (Courtesy of Eddie Chipman.)

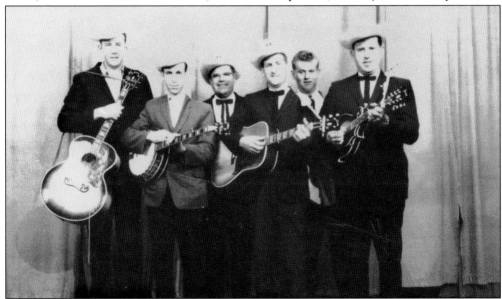

Shown here are the Grayson County Boys, a bluegrass band from Western Kentucky that established its musical reputation during the early 1960s and continued playing into the 1990s. The band pictured here dates to the 1980s and consists of, from left to right, Danny Jones, Sam Miner, Elwood Haynes, Hargis Day, Jim Purdue, and Marion Higgs. (Courtesy of Marion Higgs.)

Country music legend "Skeeter" Davis (born Mary Ann Penick) from Grant County, Kentucky, performed during the 1950s as one of the Davis Sisters. She and her sister Betty Jack performed live country music on radio stations in Cincinnati, Detroit, and Lexington, Kentucky. Betty Jack was killed in a car accident in 1953, after which Skeeter continued singing and recording as a solo act. Skeeter, who had moved to Nashville, was hired by the *Grand Ole Opry* in 1959 after her recordings began to get substantial play on the radio. Foreshadowing the current music scene, in which stars of country music such as Dolly Parton and Patty Loveless have crossed over to perform bluegrass songs, Davis was a regular performer on a bluegrass radio show hosted by Flatt and Scruggs during the 1960s. She passed away in 2004. (Courtesy of *The Encyclopedia of Northern Kentucky*.)

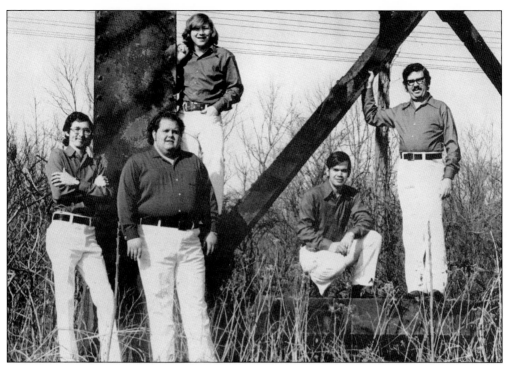

The Bluegrass Alliance from Louisville, Kentucky, was formed during the late 1960s by guitar player Dan Crary. Shown from left to right are Garland Shuping, Pete Corum, Jack Lawrence, Ronnie Privette, and Lonnie Peerce. Included among the band's previous members was Kentuckian Sam Bush on mandolin. The Bluegrass Alliance is credited with being the first band to use Ebo Walker's term "newgrass" to describe progressive bluegrass music; the band broke up in 1978. (Courtesy of *Bluegrass Unlimited*.)

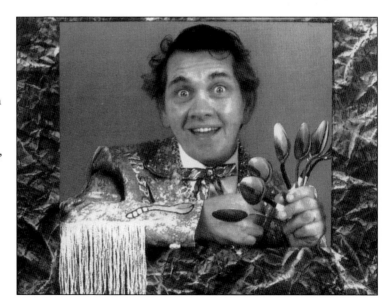

"Mr. Spoons" (Joseph Jones), whose motto was "Have spoons, will travel," was an international-competition champion on spoons and bones and was a regular on the Kentucky bluegrass circuit. Jones' work with spoons was reminiscent of the time in 1939 when spoons player Tommy Millard performed as one of Bill Monroe's Blue Grass Boys. (Courtesy of Eddie Chipman.)

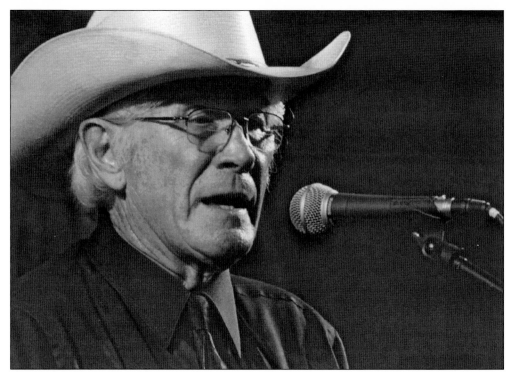

The 2001 Bluegrass Hall of Fame inductee Melvin Goins lives in Cattletsburg, Kentucky. Melvin began performing on a morning radio show in Bluefield, West Virginia, with his brother Ray in 1951. From 1953 until 1969, the Goins brothers performed with the famed bluegrass band the Lonesome Pine Fiddlers. Melvin currently heads the band Melvin Goins and Windy Mountain. (Courtesy of Melvin Goins.)

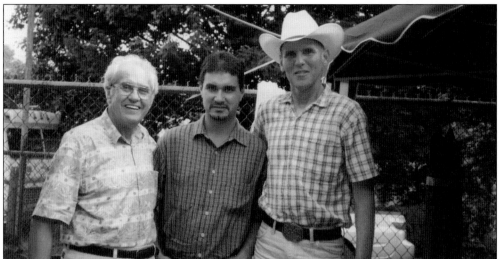

Ray Goins, who was inducted into the Bluegrass Hall of Fame in 2001 along with his brother Melvin, is shown here with his son Tim (center) and Kentucky bluegrass fiddler Michael Feagan. Goins, who made his home in Pikeville, Kentucky, performed with his brother on radio in 1951 and 1952 as the Goins Brothers. Ray retired in 1997 and passed away in 2007. (Courtesy of Gene Thompson.)

Bill Livers, a stringed-instrument player and singer from Owenton, Kentucky, began his music career in 1928. During the 1950s and 1960s, he became one of only a few African Americans to perform bluegrass music professionally. He won acclaim as one of the most versatile musicians in Kentucky during his lifetime (1911–1988). (Courtesy of Eddie Chipman.)

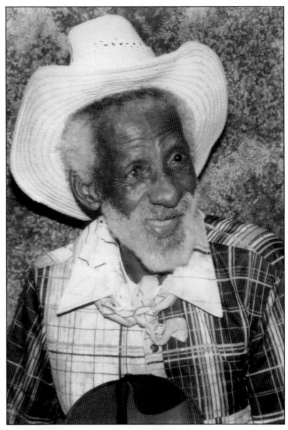

Juett Fortner was a country and bluegrass musician from Grant County, Kentucky, who had a musical career that extended from the 1940s into the late 1970s. Here Juett (seated in center) is shown chatting with Eddie Chipman (left); Juett's brother, musician Jackie Fortner; and Jimmy Skidmore (far right) in Chipman's music studio near Dry Ridge, Kentucky. (Courtesy of Eddie Chipman.)

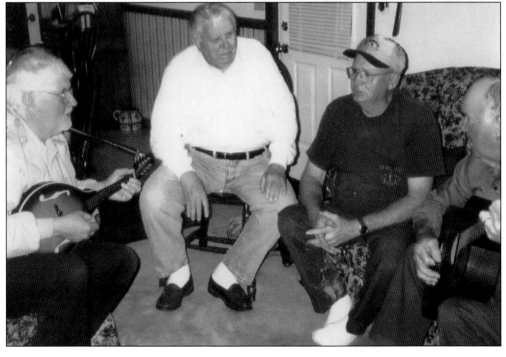

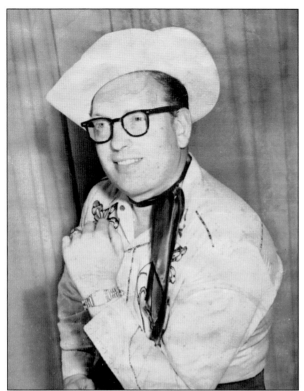

In this 1960s picture, Nelson Young, from Breathitt County, Kentucky, is shown dressed as a cowboy at a time when he mainly sang country music. He would later perform bluegrass as well. Young hosted an early morning live music show during the 1960s on radio in Cincinnati called *Rural Route 12*. (Courtesy of Vernon McIntyre.)

Kentuckians Nelson Young (second row with fiddle) and Don Boone (second row with bass) headed a popular 1950s bluegrass band called the Shady Valley Boys. For a time, this band performed regularly at the Silver Dollar Café in Cincinnati. Young later worked as a musician at the Disney entertainment complex in Orlando, Florida. (Courtesy of Vernon McIntyre.)

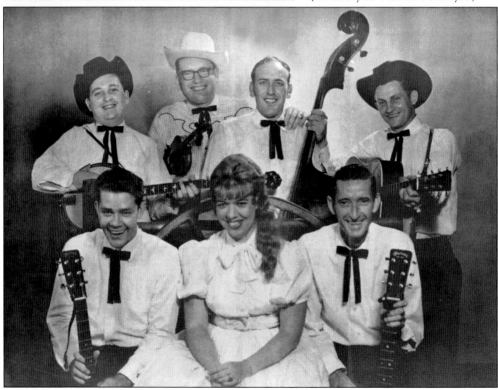

*Five*

# THE 1970S

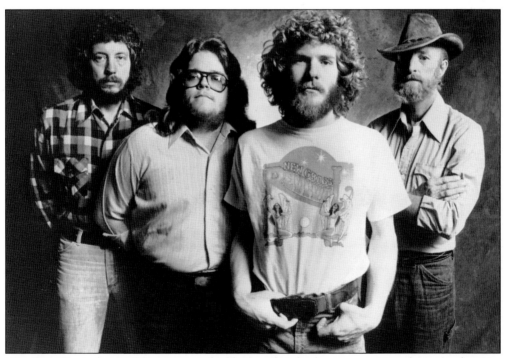

New Grass Revival, one of the most popular bluegrass bands of recent years, is no longer performing. The band was formed in Louisville by 19-year-old Sam Bush in 1971. Members shown in this 1976 photograph are, from left to right, Curtis Burch (guitar and dobro), John Cowan (bass guitar), Sam Bush (mandolin), and Courtney Johnson (banjo). Onetime band member Ebo Walker (not pictured) coined the term "newgrass" to describe the band's fast-paced music. (Courtesy of *Bluegrass Unlimited*.)

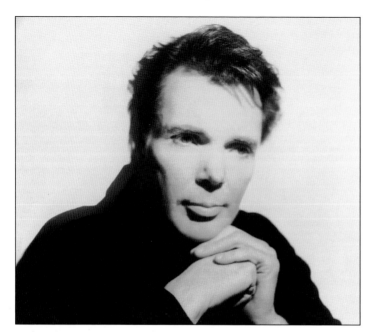

Harley Allen was the son of bluegrass pioneer Red Allen. In 1975, Harley replaced his father in J. D. Crowe's band, the Kentucky Mountain Boys. Harley won a Grammy in 2000 for his work on the soundtrack of the movie *O Brother, Where Art Thou?* and in 2005 was BMI's songwriter of the year. (Courtesy of *Bluegrass Unlimited*.)

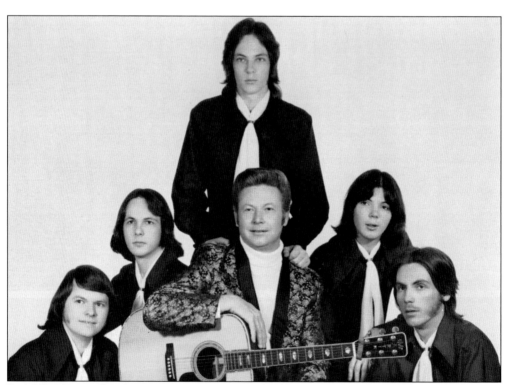

Red Allen (pictured in the center with guitar) was from Pigeon Roost, Kentucky. He founded his first band, the Kentuckians, during the early 1950s. During the late 1960s, he worked with J. D. Crowe and Doyle Lawson in the Kentucky Mountain Boys band. In the 1970s, he performed with his sons Harley, Greg, and Neal as Red Allen and the Allen Brothers. (Courtesy of *Bluegrass Unlimited*.)

Bluegrass music personality Paul "Moon" Mullins (center), of Traditional Grass, was from Frenchburg, Kentucky. Mullins, a fiddler who spent nearly 45 years playing, promoting, and broadcasting bluegrass music, is credited with helping to popularize and sustain interest in bluegrass music among his large listening audience of Appalachians. Mullins was named broadcaster of the year and received a distinguished service award in 2000 from the IBMA. (Courtesy of *Bluegrass Unlimited*.)

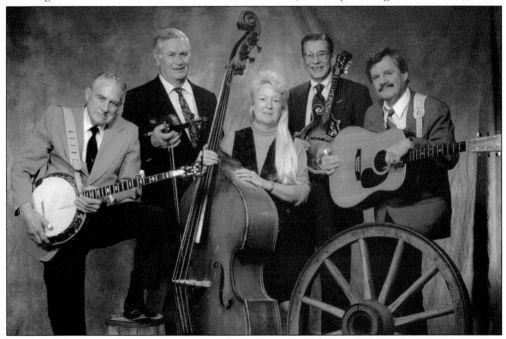

Pictured here are Clark County, Kentucky's Homer Ledford and the Cabin Creek Band, a popular Kentucky-based band Ledford assembled in 1976. From left to right are Rollie Carpenter, Marvin E. Carroll, Pamela Case, Homer Ledford, and L. C. Johnson. (Courtesy of Bluegrass Heritage Museum.)

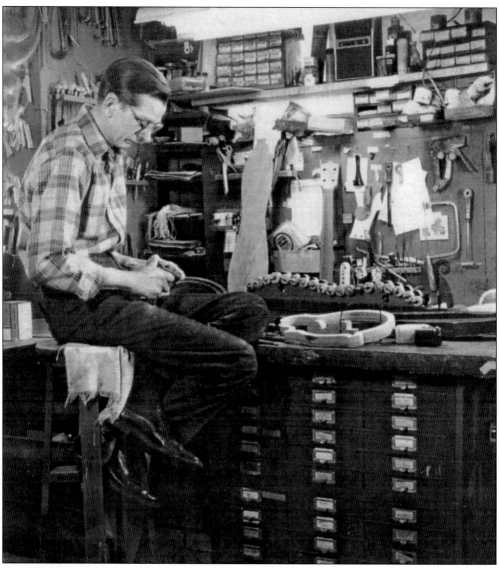

Kentucky's renowned stringed-instrument maker and bluegrass musician Homer Ledford (1927–2007) is shown working in his workshop in Clark County, Kentucky. Homer, who taught industrial arts at Clark County High School from 1954 to 1963, began making stringed instruments in his workshop in 1949. His first fiddle was crafted in 1942 while he was a teenager; he made his first dulcimer in July 1946. It is estimated that during his lifetime Ledford made 5,320 dulcimers, 395 banjos, 23 guitars, 12 mandolins, 3 fiddles, and 1 autoharp. His handmade instruments are highly collectible and command premium prices when offered for sale. Ledford was also an accomplished bluegrass performer. In 1976, he formed the popular Kentucky bluegrass band known as Cabin Creek. This band was a regular on the Kentucky bluegrass circuit and during the 1990s also performed 30-minute shows on radio station WSKV in Stanton, Kentucky. (Courtesy of the Bluegrass Heritage Museum.)

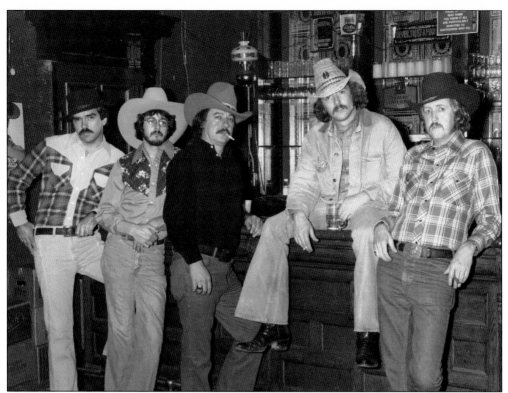

Shown here is a photograph of J. D. Crowe and the New South, a group Crowe formed in 1974. From left to right are Jimmy Gaudreau, Mike Gregory, Bobby Slone, Keith Whitley, and J. D. Crowe. Whitley, who was from Sandy Hook, Kentucky, played with Crowe from 1981 to 1985. He later gained considerable fame as a country artist before his death in 1989 from alcohol poisoning. (Courtesy of *Bluegrass Unlimited*.)

The Bluegrass Thoroughbreds, who are no longer performing, were a popular band of the 1970s based just outside of Lexington, Kentucky. The two musicians on the left are the husband-and-wife team of Marcie and James Malicote, the founders of the band. (Courtesy of Gene Thompson.)

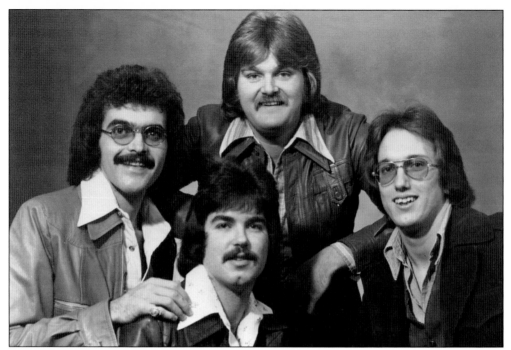

Boone Creek was formed in 1977 by mandolin player Ricky Skaggs (top center) and dobro player Jerry Douglas (far right); other members were banjo player Terry Baucom (far left) and guitarist Wes Golding (bottom center). After recording one album for Sugar Hill Records, the group broke up when Skaggs left and took a job with country singer Emmy Lou Harris's Hot Band. (Courtesy of *Bluegrass Unlimited*.)

The once popular bluegrass band the Boys from Indiana once included two Kentuckians: one of the band's founders, fiddler Paul "Moon" Mullins from Frenchburg, and banjo player Noah Crase from Barwick. Four of the band members shown in this photograph are members of the Holt family: unidentified banjo player, Harley Gabbard (Uncle to the Holts), Vernon Derrick, unidentified, Jerry Holt, Tom Holt, and Aubrey Holt, all of whom are from Sunman, Indiana. (Courtesy of Gene Thompson.)

Shown here is the bluegrass band Clyde and Marie Denny and the Kentuckians. This band was based in Burgin, Kentucky, and played the Kentucky bluegrass circuit during the late 1960s and 1970s. Marie and Clyde Denny are sitting on the fence overlooking a central Kentucky horse farm. (Courtesy of Eddie Chipman.)

Posing for a publicity shot in a central Kentucky horse pasture is the original Appalachian Grass, a popular bluegrass/country band from the 1970s. From left to right are Vernon McIntyre, Charlie Hoskins, Don McIntyre, and Jim Sullivan. The modern-day version of this band is also called Appalachian Grass. (Courtesy of Vernon McIntyre.)

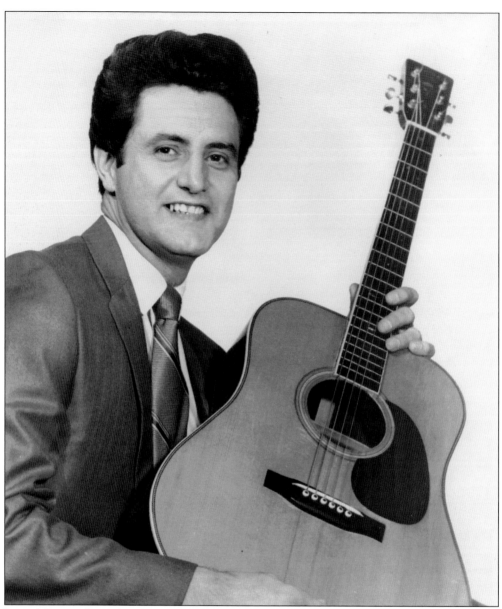

James Monroe, shown here in a 1974 publicity photograph, was the only son of Bill Monroe. James grew up in his father's shadow but soon learned to profit from the onstage experiences he had while performing with his dad. James has developed his own unique style of singing and of playing the guitar, which was described recently "as pure Monroe in nature but totally James in spirit." James learned and honed his craft by performing as one of his father's Blue Grass Boys from 1964 to 1971, after which he struck out on his own. Along the way, James Monroe has played every bluegrass festival of note, has appeared regularly on the Ryman Auditorium stage with the *Opry*, and has played Carnegie Hall in New York and Royal Albert Hall in London. James currently heads his own band, James Monroe and the Midnight Ramblers. He also administers his father's estate and operates the James Monroe Bluegrass Music Hall and Campgrounds in Franklin, Kentucky. Like his father, James is a gifted songwriter and gospel singer. (Courtesy of Gene Thompson.)

John Cowan, the former bass player and lead vocalist with New Grass Revival (1974–1990), hails from Louisville, Kentucky. Often referred to as "Johnny C.," Cowan has recorded and performed with a number of contemporary bands. Cowan formed his own band, the John Cowan Band, in 1998. (Courtesy of *Bluegrass Unlimited*.)

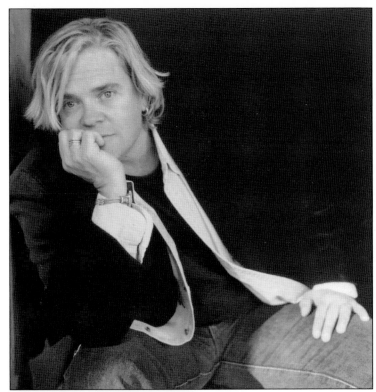

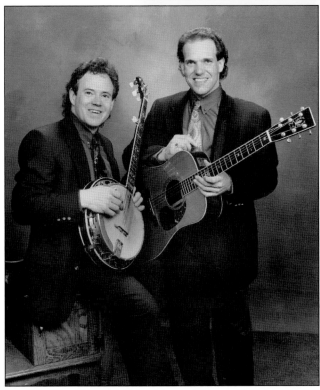

Bluegrass musicians Raymond McClain (right) and his brother Michael are shown in this late-1970s or early-1980s photograph. Both brothers sang in their early years as members of the well-known McClain Family Singers from Berea, Kentucky. Raymond is involved with the bluegrass music program at East Tennessee State University, and Michael has formed his own bluegrass band. (Courtesy of Berea College.)

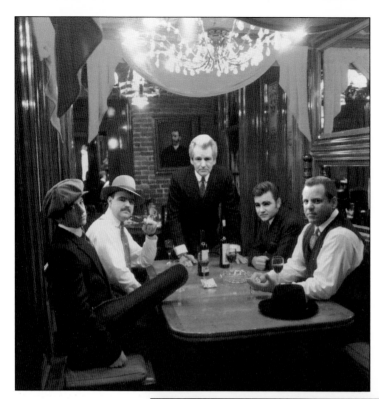

Del McCoury, who sang lead and played banjo and guitar with Bill Monroe and the Bluegrass Boys in 1963 and 1964, remains one of the most popular musicians in bluegrass music. McCoury and his band, which includes his sons Rob and Ronnie, play classic bluegrass music. From left to right are Jason Carter, Mike Bub, Del McCoury, Rob McCoury, and Ronnie McCoury. (Courtesy of *Bluegrass Unlimited*.)

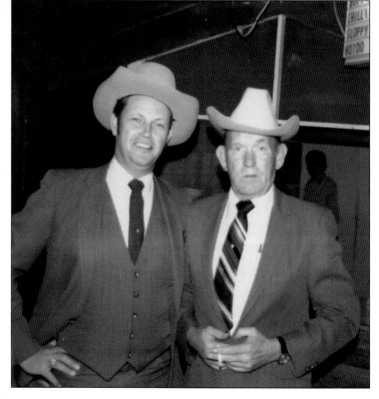

Shown in this picture are Wayne Lewis (left) and Kenny Baker, two Kentuckians who played with Bill Monroe's Blue Grass Boys. Baker was Monroe's favorite fiddle player, and Lewis, who played guitar and sang lead, played guitar in Monroe's band from 1976 to 1986, making him its longest tenured guitar player. (Courtesy of Jim Peva.)

Onetime Kentucky resident Vernon McIntyre (far left), who owns the Famous Old Time Music Company in Wapakoneta, Ohio, is shown here with his wife, Kitty (center with fiddle). Vernon has played bluegrass music for over 50 years. For a time, Vernon was the banjo player in Jimmy Martin's band. McIntyre still performs, and he also gives stringed-instrument lessons. (Courtesy of Vernon McIntyre.)

Bobby Mackey (right), whose music career stretches over four decades, is shown picking with banjo player Dale Evans. Mackey, from Lewis County, Kentucky, crossed over from country to bluegrass music when he released a bluegrass album with his band, the Pinehill Pickers, in 2008. Mackey owns a popular music center in Wilder, Kentucky, where weekly he performs country and bluegrass music with his band. (Courtesy of Bobby Mackey.)

Shown here performing solo is banjo player and vocalist Tommy Brown, who grew up near Bill Monroe's home in Ohio County, Kentucky. Tommy began picking the five-string banjo at age six. Brown, a third-generation performer in a family of musicians, also plays mandolin and guitar. (Courtesy of Mike Morbeck.)

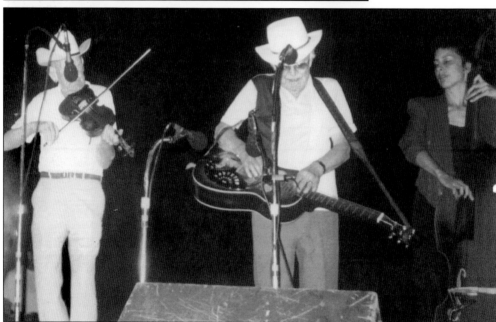

In this 1970s photograph, legendary Kentucky bluegrass fiddle player Kenny Baker (left), Josh Graves (center), and Kitty McIntyre (bass) are performing an old-fashioned hoedown at a festival in Aurora, Indiana. McIntyre, a talented fiddler in her own right, shows here how bluegrass musicians are often expected to demonstrate proficiency on several stringed instruments. (Courtesy of Vernon McIntyre.)

This is the well-known longtime banjo player and musicologist Bill Parker, from Paducah, Kentucky. Bill has been playing professionally for more than 40 years. He is respected for his dexterity on his instrument, for his teaching skills, and for his wealth of knowledge concerning bluegrass music. (Courtesy of Dan Knowles.)

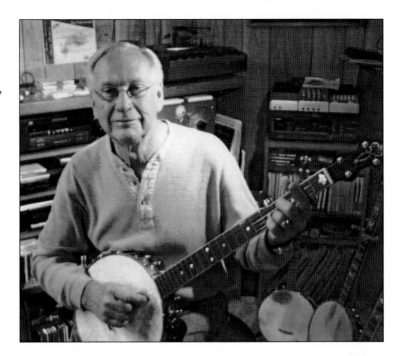

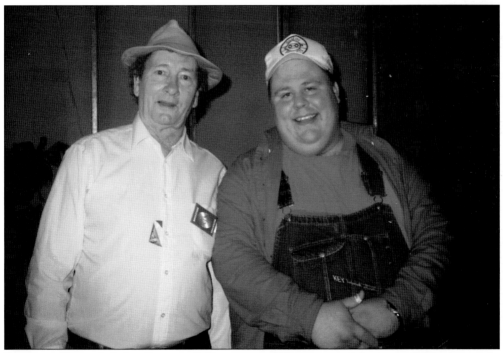

Hindman, Kentucky's Art Stamper (left) was one of bluegrass music's pioneer fiddle players. As a teen, he worked with Jim and Jesse McReynolds and the Sauceman Brothers and later, in the 1950s, with the Stanley Brothers. Stamper, who received an IBMA Distinguished Service Award in 2004, died of throat cancer in 2005. (Photograph by Becky Johnson.)

Attorney and veteran bluegrass musician Charlie Sizemore hails from Magoffin County, Kentucky. He began performing with his father and the Hal Mountain Boys band in the 1950s and also performed briefly with the Goins Brothers. In 1977, Charlie replaced Keith Whitley as guitarist and lead singer with Ralph Stanley and the Clinch Mountain Boys. Sizemore would soon be nicknamed "the Professor" by that band's members because of his love for reading and books. Sizemore remained with Stanley until 1986, when he left to form his own band and to return to school. In 1990, Charlie graduated from the University of Kentucky at the top of his class, and four years later, he completed a law degree in Nashville. He now heads a private law firm in Goodlettsville, Tennessee, where he continues his successful career as an attorney. Sizemore, who still performs bluegrass music on weekends with the Charlie Sizemore Band, recorded an album, *Good News*, on Rounder in 2007 and currently has another album underway. (Courtesy of Gene Thompson.)

## Six

# Classic and Progressive Bluegrass

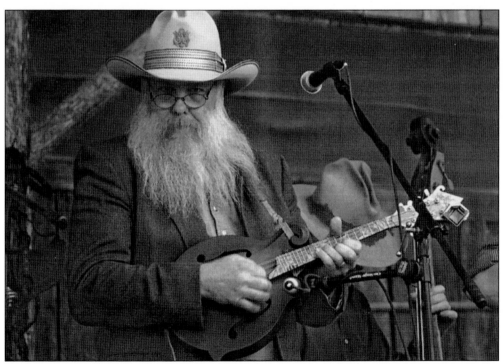

Kentuckian Duane Patterson heads the bluegrass band the Red River Ramblers. Duane, who has a long beard, reminds audiences of the times when old-time country and bluegrass musicians commonly performed with beards. This theme was repeated in the hit movie *O Brother, Where Art Thou?*, when actor George Clooney wore a fake long beard as the lead singer of the Soggy Bottom Boys. (Courtesy of Doc and Julie Mercer.)

Sam Wilson, who led a band formed in 1968 called the Kentucky Mountain Ramblers, is from Wolfe County, Kentucky. He is shown here sitting in as lead singer and guitarist with the Ralph Stanley Band some time during the 1980s in Crum, West Virginia. Wilson currently heads the Bluegrass Colonels, based in Campton, Kentucky. (Author's collection)

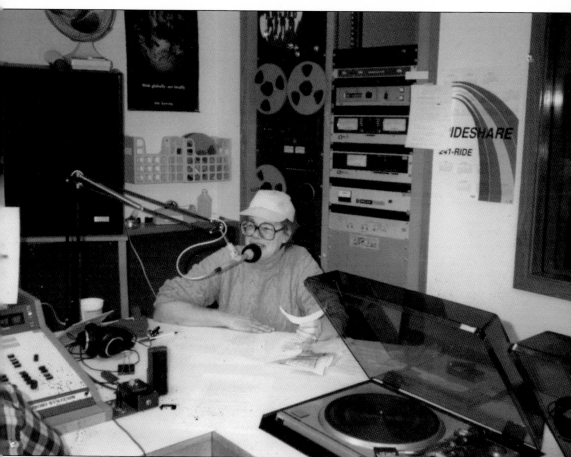

Bluegrass vocalist and guitar player Katie Laur resided for many years in Covington, Kentucky; she currently makes her home in Cincinnati, Ohio. Laur, who comes from a family of musicians, has been singing and playing music since childhood. She is a regular on the Ohio-Kentucky-Indiana performing circuit and recently was honored by her friends at an event in Covington, Kentucky, commemorating her lifetime of musical achievements. Katie has recorded several albums, many of which are now collector's items. For a time in the 1980s, Laur headed an all-girl bluegrass band, something rather unusual for bluegrass music at the time. Katie has appeared several times on Garrison Keeler's radio show, *A Prairie Home Companion*. Here she is shown broadcasting on her weekly Sunday night bluegrass show on Northern Kentucky University's public radio station in Highland Heights, Kentucky. (Courtesy of Katie Laur.)

The Lonesome River Band is a popular contemporary bluegrass band that has undergone several changes. Berea Kentucky's Jeff Parker is shown here on mandolin. Current band member Mike Anglin, not pictured here, is a bass player from Richmond, Kentucky. (Courtesy of *Bluegrass Unlimited*.)

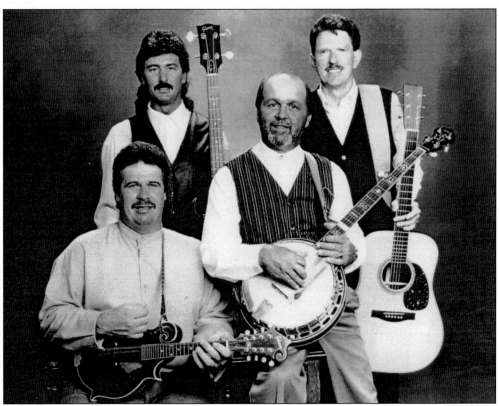

In this picture of the popular contemporary bluegrass band Wilderness Trail, lead/harmony vocalist and bass player Jeff Parker (from Berea, Kentucky) stands at top left. The other band members are David Osborne (guitar and harmony vocals), Terry Wolfe (banjo and vocals), and Bobby Master (mandolin and vocals). (Courtesy of Gene Thompson.)

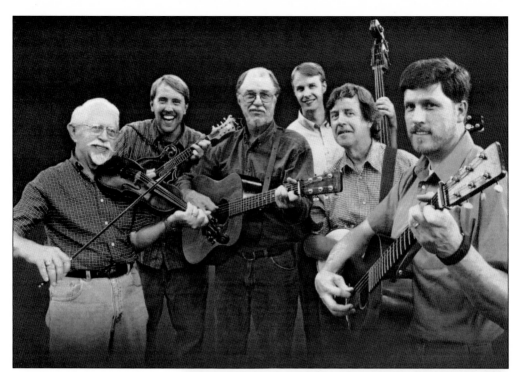

Longtime bluegrass musician and Kentucky music authority John Harrod is from Owenton, Kentucky. He is standing third from left playing guitar in the band Kentucky Wild Horse. Other band members, shown from left to right, are Paul David Smith, Jeff Keith, Kevin Kehrberg, Jim Webb, and Don Rogers. (Courtesy of John Harrod.)

Ted Belue is a Bobby Thompson–style banjo player and historian at Murray State University in Kentucky. Belue, who has been performing bluegrass music for many years, is a popular teacher at Murray State and an expert on the life of Bill Monroe. Professor Belue is also an authority on Native American cultures. (Courtesy of Dan Knowles.)

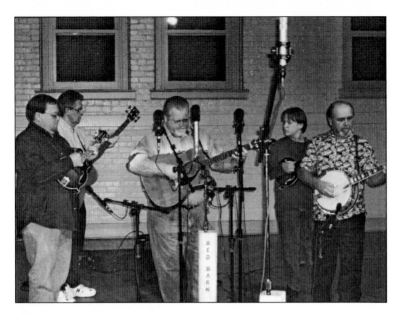

Pictured here is Gary Strong and his band, Hard Times, during a performance at *The Red Barn Radio Show* in Lexington, Kentucky. Strong, who is from Newport, Kentucky, has been performing bluegrass music since his early teens. He and his band are Kentucky bluegrass circuit regulars. (Courtesy of Ed Commons.)

# THANK YOU GARY STRONG
## FOR KEEPING
## BLUEGRASS ALIVE!
### ... Tony McMahan

This sign, located at the Star Theater in Williamstown, Kentucky, is a fan's way of thanking Newport, Kentucky's Gary Strong for helping to keep bluegrass music alive. Strong does a weekly bluegrass radio program in Batavia, Ohio, that can be heard in Kentucky. He also promotes and is a performer at the bluegrass shows held at the Star Theater. (Courtesy of Gene Thompson.)

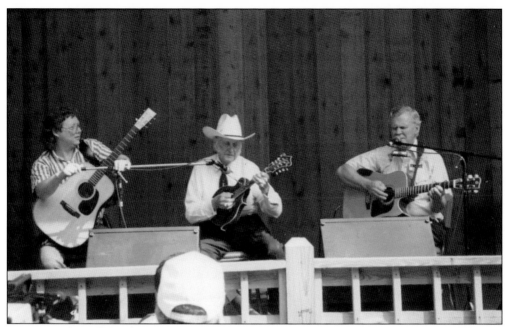

Two music legends, Bill Monroe (center) and Doc Watson (right), are seen here performing with Jack Lawrence some time during the 1980s on stage at Bean Blossom, Indiana. When they performed together no other instruments were needed, as their voices blended perfectly. Monroe later wrote a mandolin tune "Watson's Blues," which grew out of the two men's performances together. (Courtesy of Jim Peva.)

Bluegrass music is often about close friendships, such as the one that developed between Bill Monroe and Ricky Skaggs. The first time Skaggs was on stage with Monroe was in Martha, Kentucky, when Skaggs was six years old. In what is now regarded as a historic moment, Monroe called Skaggs out of the audience that evening to perform on stage with the Blue Grass Boys. (Courtesy of Jim Peva.)

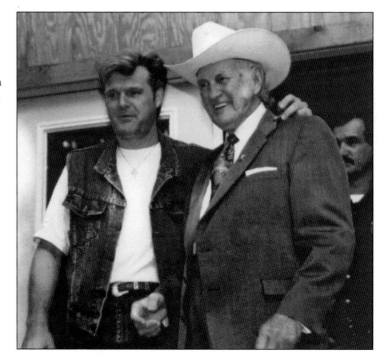

Bluegrass/gospel vocalist Jeff Newsome was raised in Maysville but currently resides in Stanton, Kentucky. Jeff has been singing since early childhood and also plays the upright bass. In his early years, Jeff sang gospel songs in church, and he was later drawn to performing bluegrass music as well. In 1987, Jeff joined a bluegrass band called Newsouthwind as a vocalist and bass player. On the band's album *Little Mountain Church*, Jeff was the lead singer for the gospel songs and played bass. His next job in music was singing lead and playing bass with the band Southern Harvest (1989–1992). Jeff specializes in singing old-time gospel songs, and his love for these brought him into contact with Rickey Wasson, one of Kentucky's most talented bluegrass gospel singers. Wasson and Newsom combined to produce the 2007 bluegrass/gospel album *Jeff Newsome, Family and Friends*, which featured several old-time gospel classics such as "Jesus Hold My Hand" and "I'm Gonna Have a Little Talk." (Courtesy of Jeff Newsome.)

Personable bass vocalist and guitar player Rickey Wasson operates a music store in Clay City, Kentucky, during the week and performs bluegrass and gospel music on the weekends. Rickey is lead vocalist and guitarist with J. D. Crowe and the New South, one of bluegrass music's most popular bands. Wasson began playing bluegrass when he was four years old. He has been quoted as saying he never knew there was any other kind of music. In 1984, Wasson formed a bluegrass band known as Southern Blend. For a short time, he filled in with Alison Krauss's band as a guitar player. Rickey joined Crowe's band in 1998. Wasson is the band's front man during performances, never forgetting, however, that the real star on stage to Rickey's right (who many in the audience have come just to see perform) is bluegrass legend J. D. Crowe. Rickey loves to sing gospel and currently is teamed with his friend Jeff Newsome to record gospel music. Wasson also released a solo album, *From Heart and Soul*, in 2008. (Courtesy of Rickey Wasson.)

Joe Isaacs (first row, center), from Big Hill, Kentucky, was the lead singer of the bluegrass/gospel group known as the Isaacs. Prior to turning to gospel music, Joe played guitar with the Stanley Brothers and also with Frank Wakefield and the Greenbriar Boys. (Courtesy of *Bluegrass Unlimited*.)

Pictured here are the bluegrass gospel singers from Kentucky known as the Born Again Singers. From left to right are Frank K. Jennings (guitar), George Angel (guitar), Bob Floor (vocal harmonies), Pat Jennings (guitar), Sherrill Jennings (banjo), and June Jennings (vocalist). (Courtesy of Eddie Chipman.)

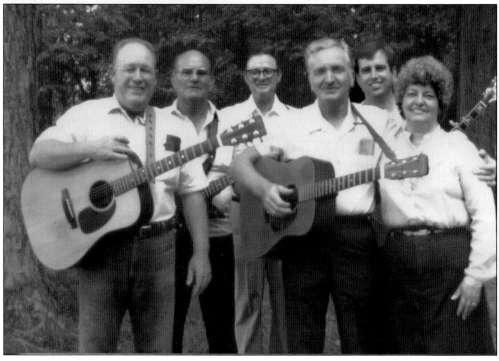

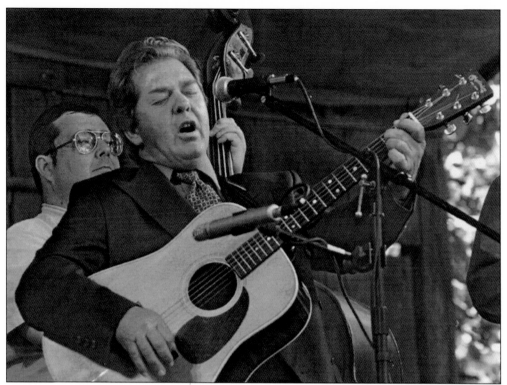

Rick Prater is from Knott County, Kentucky. At one time, Rick played guitar and sang with the Lonesome Ramblers, a band formed by Larry Sparks in 1969. Prater now heads Rick Prater and the Midnight Travelers, one of the most popular bands on the Kentucky bluegrass circuit. (Courtesy of Mike Morbeck.)

Kentuckian Paul Adkins is lead singer and guitarist in the talented bluegrass ensemble Paul Adkins and the Borderline Band. Adkins, who replaced Kentuckian Keith Whitley as lead singer and guitarist with J. D. Crowe and the New South, has headed his own band since 1988. (Courtesy of *Bluegrass Unlimited*.)

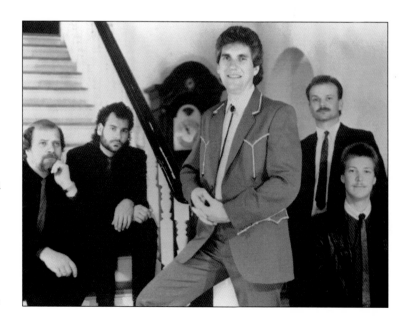

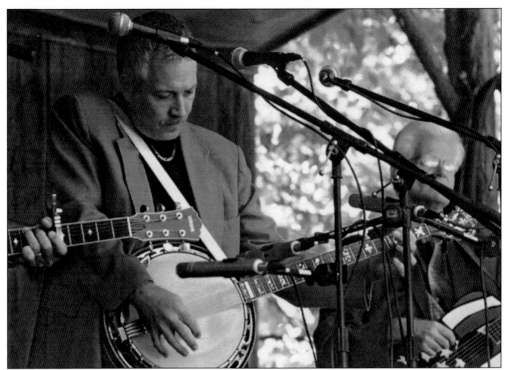

Westport, Kentucky's Gary Brewer (banjo) performs with the Kentucky Ramblers during a bluegrass show in Lexington, Kentucky. Gary, whose career began in the 1970s, is a bluegrass musician whose family's musical heritage stretches back six generations; Brewer proudly refers to himself as "the Voice of Tradition." (Courtesy of Mike Morbeck.)

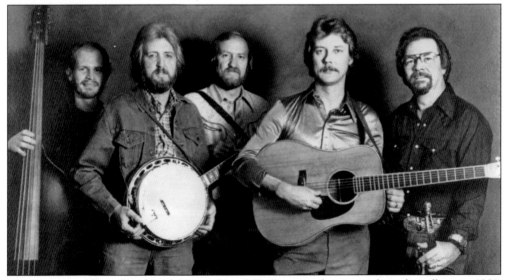

The Bluegrass Album Band, with Kentuckian J. D. Crowe on banjo, made its first album in 1981. In 1990, they won the IBMA award for Instrumental Group of the Year. Personnel included Tony Rice (guitar), J. D. Crowe (banjo), Doyle Lawson (mandolin), Bobby Hicks (fiddle), Todd Phillips (bass), Jerry Douglas (dobro from the third album on), and Vassar Clements (fiddle from the fifth album on). (Courtesy of *Bluegrass Unlimited*.)

These are the members of the New Coon Creek Girls (from the 1980s), an all-girl bluegrass band based out of Renfro Valley, Kentucky, that was inspired by the famous earlier band the Coon Creek Girls. The new group soon developed a noteworthy professional reputation mirroring that of the earlier group. Clockwise from top, the members are Pam Perry, Pam Gadd, Vicki Simmons, and Wanda Barnett. (Courtesy of Pam Gadd.)

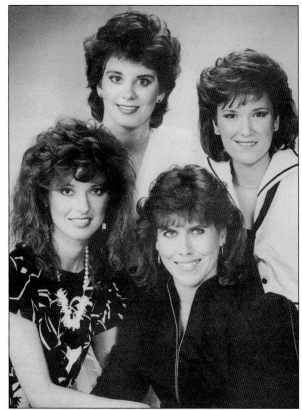

The New Coon Creek Girls was founded by Vicki Simmons in 1980. Inspired by the earlier group known as the Coon Creek Girls, the modern group, which has disbanded, experienced many changes in personnel. Finally, in 1997, the group became Dale Ann Bradley and Coon Creek. From left to right are Vicki Simmons, Dale Ann Bradley, Ramona Church Taylor, and Jennifer Wrinkle. (Courtesy of Pam Gadd.)

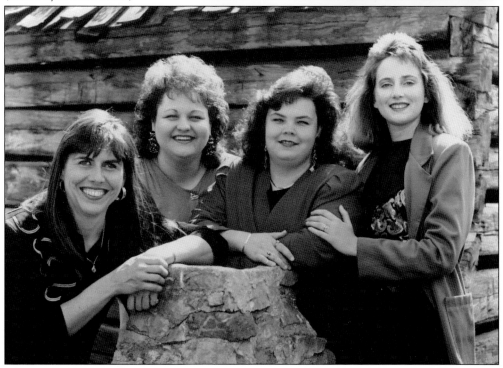

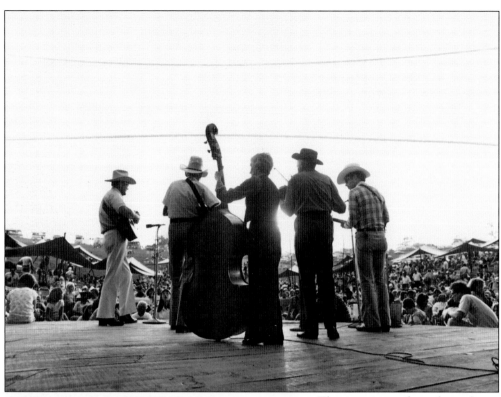

This is a picture from the early 1980s of the now-defunct annual bluegrass festival held by the McClain family on a mountaintop outside of Berea, Kentucky. The McClain Family Singers was one of the most popular singing groups in Kentucky, and both Michael and Raymond McClain, who performed with their family, became bluegrass musicians. (Courtesy of Berea College.)

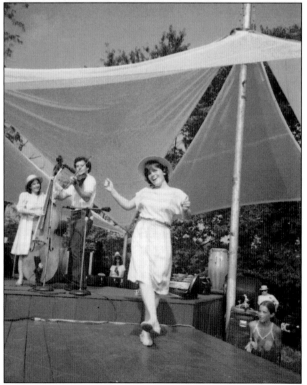

Nancy Ann McClain is pictured clog dancing at a 1980s performance by her family's band at the McClain Family Festival outside Berea, Kentucky. A picture can tell as much as a thousands words, as the joyful smile on Nancy's face while she performs this traditional Kentucky dance clearly attests. (Courtesy of Berea College.)

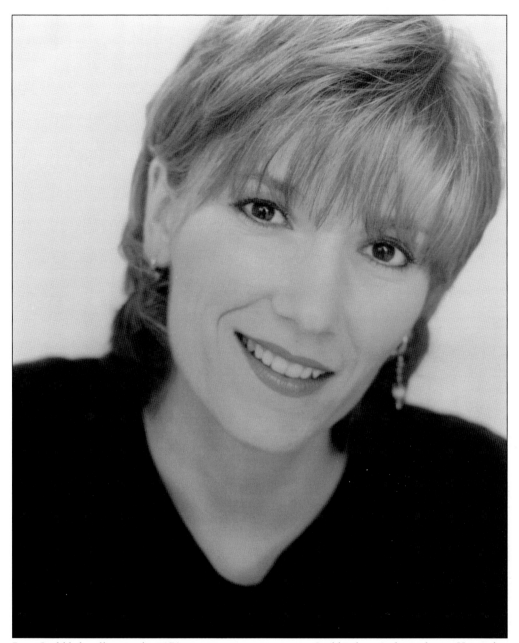

Pam Gadd left college in the 1970s to pursue a music career. Gadd is from Independence, Kentucky, and now lives in Nashville. Her first big break came when she joined Vicki Simmons and the New Coon Creek Girls in 1983. She left that group in 1987 to form her own country female group, Wild Rose. In 1995, Gadd rejoined the New Coon Creek Girls for one year before embarking on a solo career. In 1996, Gadd toured with Kentuckian Patty Loveless singing harmony and appeared with Loveless on *The Tonight Show with Jay Leno* and *Late Night with David Letterman*. Her first solo album was released in 1997, and in 1999, she was a finalist for the IBMA's Emerging Artist of the Year award. In 2001, Gadd joined OMS Records doing promotion. From 2002 until Porter Waggoner's death in 2007, she was his duet partner on the *Grand Ole Opry*. Gadd is still performing; she also works in a library and attends college. (Courtesy of Pam Gadd.)

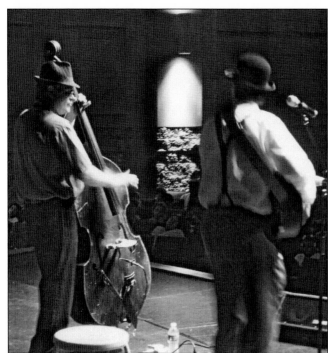

Shown here are bassist Eddie Coffee, from Paducah, Kentucky, and banjo player Dan Knowles, from Paris, Tennessee. Coffee heads the Kentucky bluegrass band Bawn in the Mash, and Knowles is a talented songwriter and instrument maker. Knowles cohosted and performed on a bluegrass show broadcast during the 1980s on Murray State University's radio station. (Courtesy of Dan Knowles.)

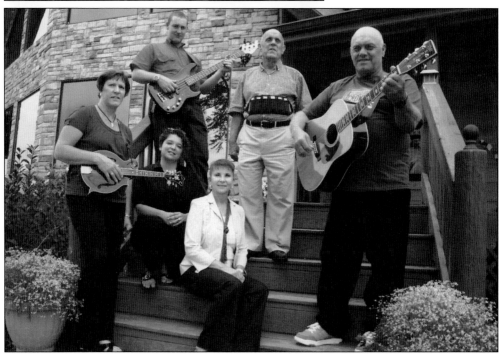

Brighter Day is a versatile bluegrass/gospel group based in Larue County, Kentucky, that features several musicians who began singing and playing music at early ages. The band consists of Leon Grimes (standing center; harmonica and vocals), Gene Grimes (guitar and vocals), Warren Grimes (bass), Joy Cox (seated, in black; vocals) Patty Chaudoin (seated, in white; vocals), and Linda Grimes (guitar, mandolin, and vocals). (Courtesy of Linda Grimes.)

*Seven*

# THE 1980s

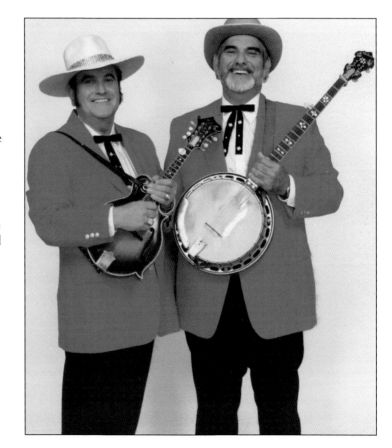

This is a classic picture of Bobby (left) and Sonny Osborne. Both brothers are from Hyden, Kentucky, but they grew up in Dayton, Ohio, because their father had moved there to find work. Bobby started out as a country singer, but in 1956, joined with his brother Sonny to form the highly successful bluegrass band The Osborne Brothers. Sonny injured his shoulder in 2004 and no longer performs. (Courtesy of Gene Thompson.)

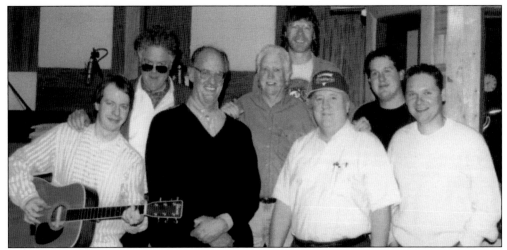

Above are the bluegrass musicians that Arthur Hancock III (from Paris, Kentucky) assembled for the album titled *The Sunday Silence Project*. Hancock, owner of the 1989 Kentucky Derby winner Sunday Silence, has played bluegrass music since age 11. Pictured here are, from left to right, (first row) Stuart Duncan, Arthur Hancock, Bill Vorndick, and Mark Fain; (second row) Peter Rowan, J. D. Crowe, and Brian Sutton; (third row) Sam Bush. (Courtesy of Arthur Hancock III.)

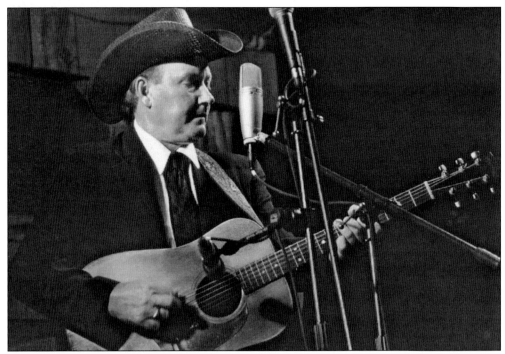

Sammy Adkins, of Sandy Hook, Kentucky, is the featured singer with the Sandy Hook Mountain Boys. Sammy got his big break in 1986 when he replaced Kentuckian Charlie Sizemore as rhythm guitarist and lead singer with Ralph Stanley and the Clinch Mountain Boys; Adkins left in 1990. (Courtesy of Mike Morbeck.)

Tommy Webb lives in Langley, Kentucky, a few miles from Route 23, the famed highway that has produced so many country and bluegrass stars. Webb began singing and playing guitar at age 15 in local jam sessions. His first job in bluegrass was with the Pine Top Ramblers, followed by stints with South Creek and Onlyne. In 2005, Tommy formed his own band, the Tommy Webb Band. (Courtesy of Tommy Webb.)

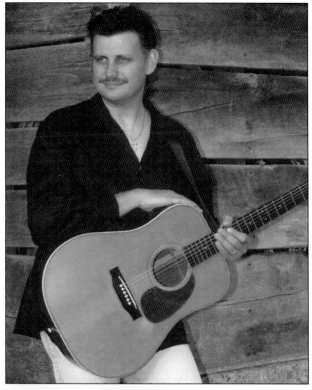

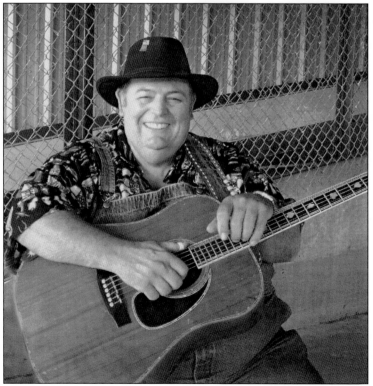

Recognized as one of the most talented thumb-pick guitar players currently performing, Eddie Pennington lives in Princeton, Kentucky. Eddie is a regular performer at Kentucky bluegrass festivals, especially those held in western Kentucky. He is famous for his interactions with crowds and his ability to play their song requests. (Courtesy of Sharon Claypool.)

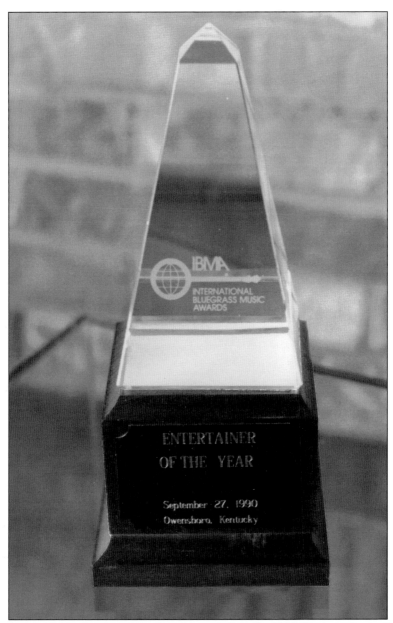

This is a picture of one the award trophies presented at the IBMA's annual award ceremony. Currently, 19 awards are presented each year in a variety of categories, including new hall of fame members, entertainer of the year, vocal group of the year, male singer of the year, female singer of the year, song of the year, album of the year, and emerging artist. This comprehensive organization for bluegrass music, which is now headquartered in Nashville, Tennessee, was established in 1985 in Owensboro, Kentucky. Art Menius, who later became the director at the Appalshop in Whitesburg, Kentucky, was selected as the IBMA's first executive director. The IBMA held its first gated Fan Fest in Owensboro in 1987 and later moved the shows to Louisville. The organization moved its staff, offices, and programming to Nashville in 2003. The annual IBMA awards program is now broadcast over an extensive network of radio and television stations. (Photograph by Becky Johnson.)

Ricky Skaggs, of Cordell, Kentucky, is shown accepting the 1985 Country Music Association (CMA) entertainer of the year award. During the 1990s, Skaggs turned back from performing country music and rededicated himself to the performance of bluegrass music. Skaggs began performing country music with his family at age six and at age seven played and sang on the *Flatt and Scruggs* television show. (Photograph by Melodie Gimple.)

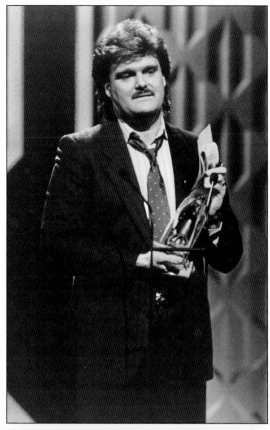

Jim Hurst, from Glasgow, Kentucky, plays guitar, banjo, bass, mandolin, and dobro and is shown receiving one his IBMA awards (2001 and 2002) as guitar player of the year. In recent years, Jim has performed with famed bluegrass bass player Missy Raines as well as with fellow Kentuckian John Cowan. (Courtesy of Dana Locke.)

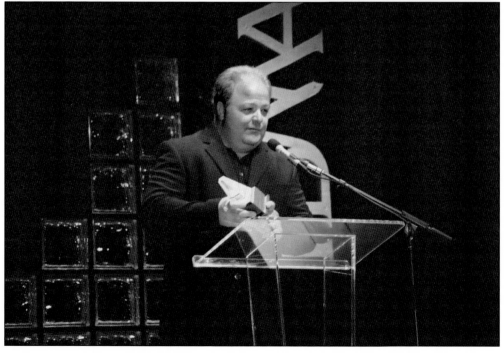

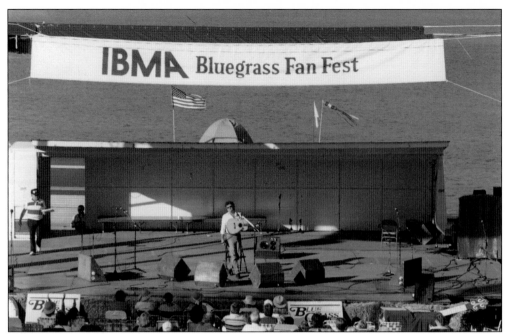

The IBMA's popular bluegrass music festival, known as Fan Fest, was first held in Owensboro, Kentucky, in 1987. A few years later, the IBMA moved its programming to Louisville; today the IBMA conducts all of its public and broadcasted programming from its new hometown of Nashville. (Photograph by Becky Johnson.)

This is a 2007 photograph of the annual bluegrass festival held at the Monroe family's properties at Jerusalem Ridge in Ohio County, Kentucky. The festival, which began in 2002, draws several thousand fans; many famous bluegrass musicians have performed at the festival at reduced fees in tribute to Monroe and to help support the nonprofit foundation that oversees the properties. (Courtesy of Mike Morbeck.)

This is the veteran Kentucky-based group King's Highway performing on stage during the bluegrass festival held each year at the Monroe family's homestead on Jerusalem Ridge in Rosine, Kentucky. This popular bluegrass five-man ensemble features Mark Fulkerson on mandolin and Josh Johnston on guitar. (Courtesy of Mike Morbeck.)

Hindman, Kentucky's Vince Combs, of Vince Combs and Shadetree Bluegrass, is shown belting out a song at a bluegrass festival. Combs, a veteran bluegrass performer who once performed with Hylo Brown, plays mandolin and old-time clawhammer banjo and possesses one of the most powerful tenor voices in bluegrass music. Kentucky Highway 550, which runs through Hindman, was dedicated to Combs in 2001. (Courtesy of Mike Morbeck.)

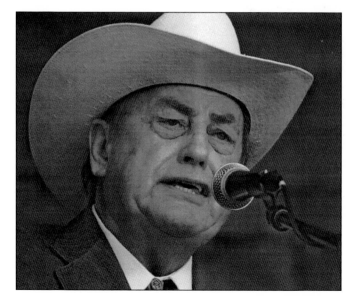

Versatile bluegrass fiddle player Steve Day is from Bowling Green, Kentucky. Day, who is a much sought-after stand-in musician, began performing professionally at age 13. He was a state fiddling champion in Kentucky and played for a time beginning in 1998 with David Parmley and Continental Divide. (Courtesy of Steve Day.)

Becky Johnson is one of bluegrass music's greatest fans and also one of its most talented photographers. Johnson, who fell in love with bluegrass music as a teen, has a weekly bluegrass radio show as "Mrs. Bluegrass" for Appalshop on WMMT-FM in Whitesburg, Kentucky. She also authored a marvelous book of photographs of bluegrass musicians that has now become a collector's item. (Photograph by of Becky Johnson.)

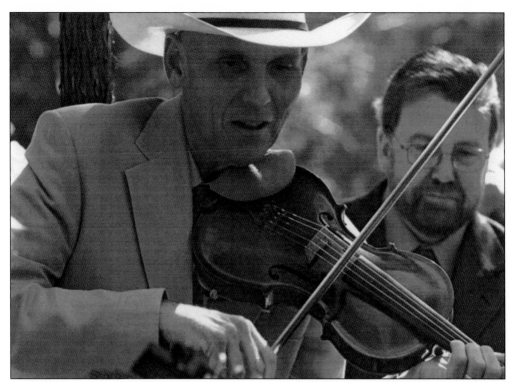

Michael Feagan, one of the most popular and talented fiddle players now performing, is from Augusta, Kentucky. Michael has been paired in instrumental duets with several top bluegrass musicians and is a yearly regular at the annual bluegrass festival conducted on Jerusalem Ridge in Ohio County, Kentucky. (Courtesy of Mike Morbeck.)

"Uncle Doc" Whilhite is one of the most colorful and popular musicians in Kentucky still performing classic bluegrass music. Doc actually is a physician who lives and practices medicine in Madisonville, Kentucky. He has performed on the bluegrass circuit for many years, and for lovers of old-time bluegrass songs, an appearance by Doc is always a treat. (Courtesy of Mike Morbeck.)

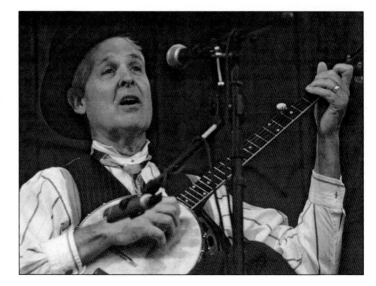

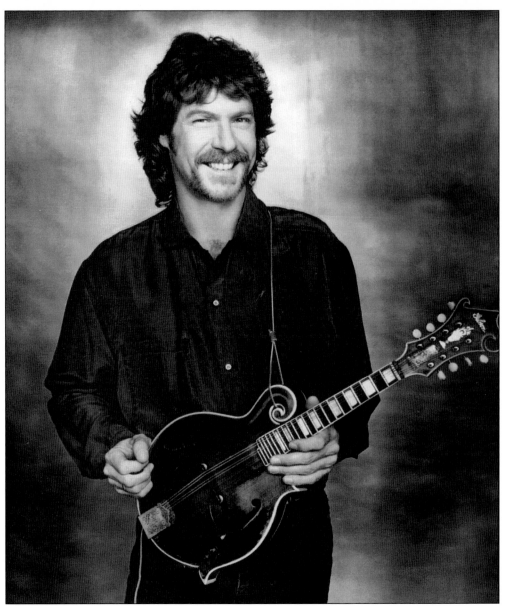

This is Bowling Green, Kentucky, native Sam Bush, one of the most respected musicians in bluegrass music. Bush was a leader of the New Grass Revival (1971–1990), and a member of this band, Ebo Walker, is credited with coining the term "newgrass" as a way to describe the avant-garde bluegrass music the band was playing. Dubbed "the world's greatest all-purpose mandolin player" by legendary bluegrass mandolin player David Grisman, Bush began learning to play mandolin at age 11. He also began playing fiddle at about that time. He was hospitalized in 1981 and operated on for cancer, which has remained in remission. Bush, who has recorded with several stars of bluegrass music, including Jerry Douglas and Tony Rice, has won many awards for playing the mandolin. Some of these include *Frets* magazine's reader's poll naming Bush best mandolin player for four consecutive years (1986–1989) and the IBMA award as best mandolin player in 1991, 1992, and 1993. (Courtesy of Vernon McIntyre.)

Pictured here performing at a bluegrass festival is Laurel County, Kentucky's talented songwriter and musician, Darrell Scott. Scott wrote the hit coal mining song, "You'll Never Leave Harlan Alive," recorded by Patti Loveless and by Lori Thornberry, both of whom are from Eastern Kentucky. (Photograph by Becky Johnson.)

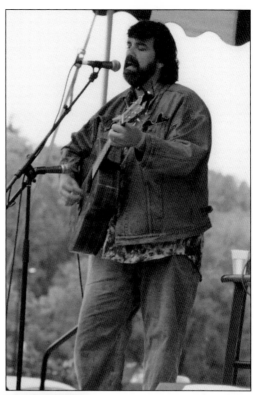

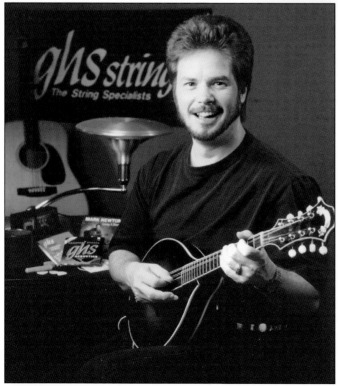

Mark Newton, of Paducah, Kentucky, began playing mandolin at age 14 in his father's band, Frog Newton and the Tadpoles. Mark has played with several other bluegrass bands since then, and his album *Follow Me Back to the Fold* won the IBMA award for recorded event of the year in 2001. (Courtesy of *Bluegrass Unlimited*.)

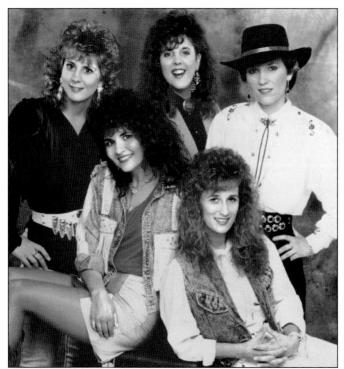

The late 1980s country/ bluegrass band Wild Rose, founded by Pam Gadd (far right), drew its inspiration from the recording successes of the New Coon Creek Girls. Gadd, who performed with the New Coon Creek Girls in the early 1980s before leaving and forming Wild Rose, returned to the New Coon Creek Girls in 1995. Pam now performs as a solo artist. (Courtesy of Pam Gadd.)

The Stringticklers of Grant County, Kentucky, was a regional bluegrass band that performed during the 1970s and 1980s. Like many such bands, its members had either performed with other bands or would later form bands of their own. Pictured here are, from left to right, Darrell Brown on mandolin, guitarist Eddie Chipman, "Bo" Woodward, a fiddle player since 1937, and Paul James on banjo (currently with the James Family Band). (Courtesy of Eddie Chipman.)

*Eight*

# SUSTAINING THE
# MOMENTUM

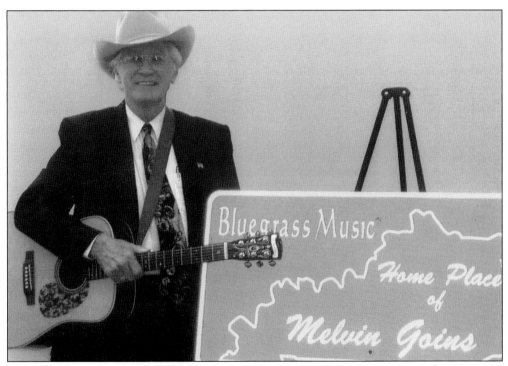

Kentucky bluegrass music legend Melvin Goins is shown posing before the sign erected on Kentucky Highway Route 23—"The Country Music Highway"—commemorating his achievements and contributions as a musician. As of 2009, Melvin has been playing bluegrass music for 59 years, and he is still going strong. Sometimes, Melvin has been known to wear colorful clown-like clothing during a performance as "Big Wilbur;" it is a surefire crowd pleaser. (Courtesy of Melvin Goins.)

Steve Gulley, pictured with the guitar, began his professional career as musical director and performer at Renfro Valley, Kentucky. From 1995 to 1998, he sang lead vocals with Doyle Lawson and Quicksilver. Gulley is shown with Mountain Heart, a group he founded in 1998 with Adam Steffey (not pictured) and fiddle player Barry Abernathy (second from the left). (Courtesy of *Bluegrass Unlimited*.)

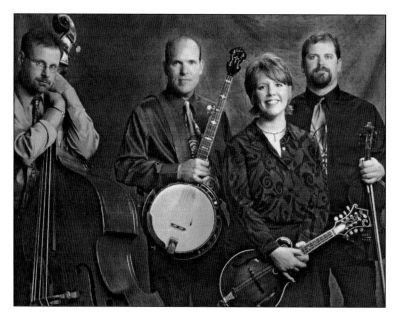

Michael McClain is shown with his contemporary bluegrass ensemble. Michael is one of the famed McClain Family Singers from Berea, Kentucky. Pictured here are, from left to right, Todd Cook (bass), Michael McClain (banjo), Jennifer Banks McClain (mandolin), and Joel Whittinghill (fiddle). (Courtesy of Michael McClain.)

Tim Cline, who heads the eastern Kentucky–based Tim Cline Band, is a second-generation bluegrass musician. His father, Curly Rae Cline, was a noted fiddle player with the Lonesome Pine Fiddlers, Bill Monroe, and David Davis. (Courtesy of Gene Thompson.)

Darrell Winkleman, a talented lead tenor, is shown harmonizing with guitarist Marty Dunn at a 2008 bluegrass festival in Kentucky. Winkleman and his band Mountain Echoes are regulars on the Kentucky bluegrass circuit, and they have the reputation of being real crowd-pleasers. (Courtesy of Mike Morbeck.)

Popular bluegrass vocalist Stacy York is from Pulaski County, Kentucky. She began singing gospel with her family at age seven and formed her own band during the 1980s at age 19. For the last eight years, she has been performing with Joe Isaacs and Mountain Bluegrass. (Courtesy of Mike Morbeck.)

Former Blue Grass Boy (1976–1986) Wayne Lewis is shown doing solo guitar work during a performance at a 2007 bluegrass festival in Kentucky. Lewis's first full-time job was with Ralph Stanley in 1974, followed by a stint with the Dixie Gospelaires in 1975. Currently, he performs with the Cumberland Highlanders and cohosts their television series on RFD-TV. (Courtesy of Mike Morbeck.)

Chain Reaction is a hard-driving bluegrass band from Walton, Kentucky. They play both new and old-style bluegrass music and credit Bill Monroe, Ralph Stanley, and Jimmy Martin as their influences. Shown from left to right are Phil Lawrence, Jamie Hall, Paul Johnston, Bud Walls, and Coy Turner. (Courtesy of Phil Lawrence.)

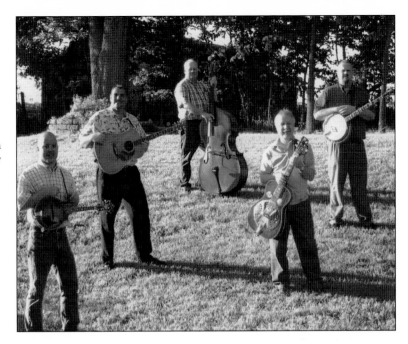

Temperance Road, a popular bluegrass band headed by the Perry family from Franklin, Kentucky, has undergone many changes over the years. Pictured here are, from left to right, members of the original band (first row) Jeremey Slayton (banjo), Sydni Perry (fiddle/vocals), and Laura Perry (mandolin/vocals); (second row) Judy Perry (bass/vocals), Wayne Perry (guitar/vocals), Richard Perry (guitar/vocals), and Bernie Sullivan (mandolin). (Courtesy of the Perry family.)

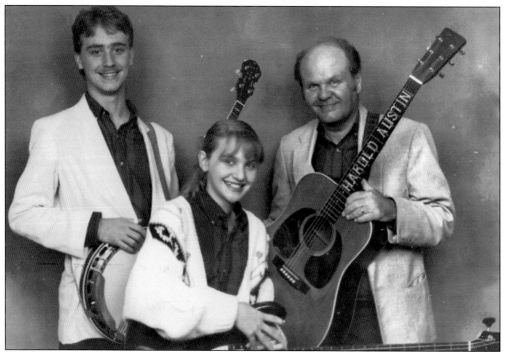

The three-member bluegrass group billed as Harold Austin and Casey Cutwell consisted of Harold Austin (left), Harold's daughter (center), and his son-in-law, Casey Cutwell (right). This Kentucky-based group, which followed the festival circuit, was known for its tight harmonies and its members' skillful instrumental breaks. (Courtesy of Gene Thompson.)

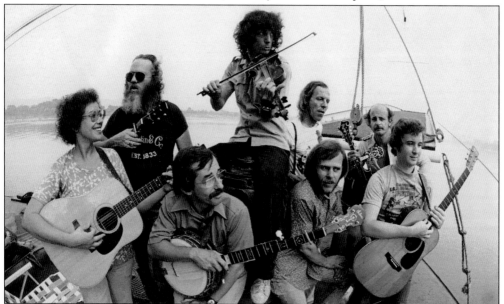

Steam-powered riverboats have long featured musical performances as part of their on-board entertainment. In this early 1980s picture aboard the historic *Delta Queen*, bluegrass musicians Katie Laur, John Hartford (center with fiddle), and Doug Dillard (to the right of Hartford) of the Dillards are shown performing on the Ohio River near Louisville, Kentucky. (Courtesy of Katie Laur.)

Al White, who was once part of the McClain Family Band, is doing a solo break with the Berea College Bluegrass Ensemble on *The Red Barn Radio Show* in Lexington, Kentucky. White heads a music program for performing bluegrass musicians established at Berea College in 1999 and routinely performs with his students. (Courtesy of Ed Commons.)

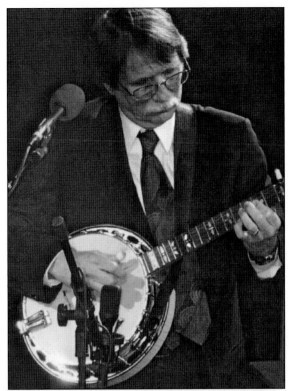

Darrell Scott, from London, Kentucky, is a contemporary bluegrass musician and songwriter who can play several stringed instruments skillfully. In 2000, Scott performed with the well-known newgrass trailblazer Tim O'Brien on an album entitled *Real Time*, featuring several songs he composed. (Courtesy of *Bluegrass Unlimited*.)

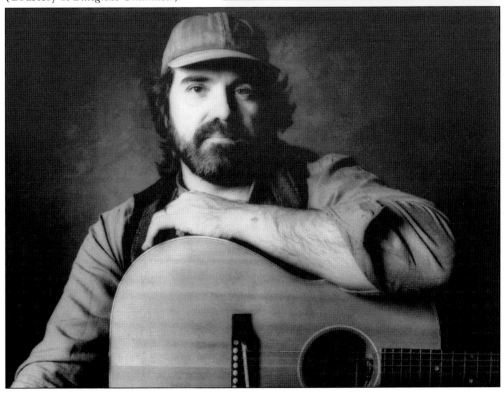

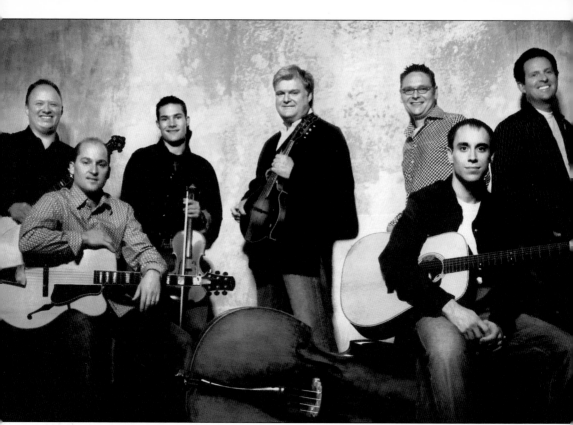

Shown here are Ricky Skaggs and his heralded bluegrass band Kentucky Thunder, which has won nine IBMA performance awards and seven Grammy awards. Each band member is a remarkable musician. Banjo player Jim Mills (far left), for example, has been the IBMA's banjo player of the year six times. Lead guitarist and vocalist Darrin Vincent (second from the left) has left the band to help found the award-winning Dailey and Vincent bluegrass band. Fiddle player Andy Leftwich (third from the left) was invited by Skaggs in 2001 to step from an audience and become a member of the Skaggs band. Skaggs, a mandolin virtuoso who also plays several other stringed instruments, is in the center. Bass player Mark Fain (fifth from the left) also plays drums and guitar. Cody Kilby (sixth from the left, in front) is a national flat-pick guitar champion. Paul Brewster (far right) sings lead and tenor vocals. (Courtesy of Tony Tackett of the Highway 23 Museum.)

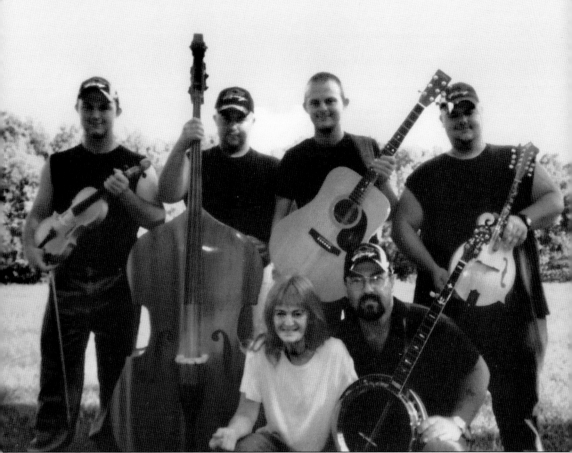

The James Family is from Corinth, Kentucky, and they have been performing bluegrass for over 15 years. Scott James (back row, far left) is noted for playing his fiddle like a cello while sitting down during the band's performances. Other members, pictured with their instruments, include Paul Jr. (vocals and bass), Robin (guitar and vocals), Daniel (mandolin and vocals), Paul (banjo and vocals), and Jean (vocals). (Courtesy of Paul James.)

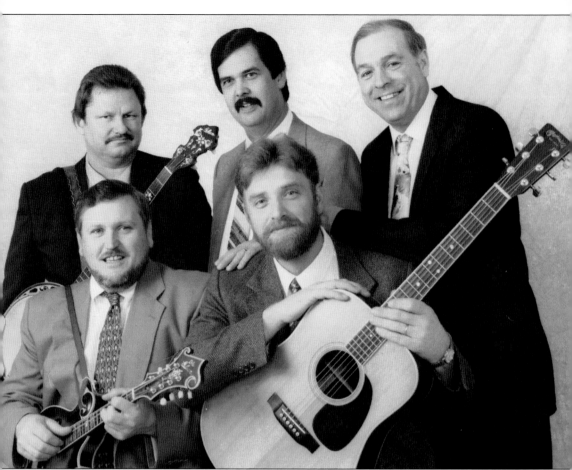

Five for the Gospel is a band from eastern Kentucky near Louisa that guitarist Rick May formed in 1991. Pat Holbrook plays bass and Johnny Branham plays banjo. In 1997, the band won the Society for the Preservation of Bluegrass Music of America's award for traditional gospel group of the year. (Courtesy of Bluegrass Unlimited.)

*Nine*

# THE MODERN BLUEGRASS CIRCUIT IN KENTUCKY

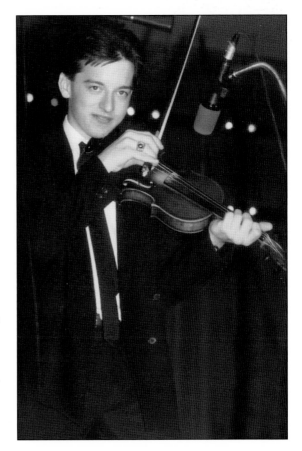

Jason Carter, a fiddle player from Green County, Kentucky, joined the Del McCoury Band at age 19. He is a three-time IBMA Fiddle Player of the Year award winner (1997, 1998, and 2003). A fiddle solo by Jason during a McCoury Band performance is always certain to be one of the show's highlights. (Photograph by Becky Johnson.)

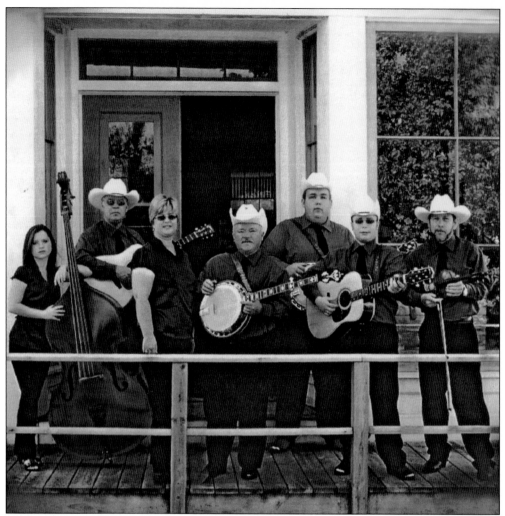

Tommy Brown's dynamic bluegrass band, County Line Grass, is based out of Mount Washington, Kentucky, and has a wide following of fans regionally. Pictured here are, from left to right, Tommy's daughter Rachel Brown (bass), Bobby Priest (guitar), Tommy's wife Laura (vocals), Tommy (banjo and vocals), Josh "Jug" Rinkel (banjo), Tommy's son Jerome (guitar), and Wayne Fyffe (fiddle). (Courtesy of Mike Morbeck.)

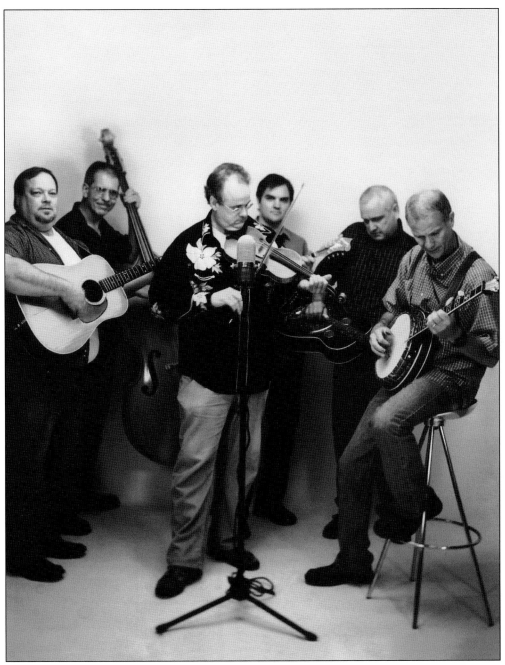

The popular contemporary bluegrass band from northern Kentucky known as the Comet Bluegrass All Stars is shown performing in 2007 at Old Coney Island in Cincinnati, Ohio. From left to right are Tim Strong, Artie Werner, Ed Cunningham, Brad Meinerding., John Cole, and Jeff Roberts. (Courtesy of Jeff Roberts.)

The talented band known as Crossroads consists of, from left to right, Jim Moore (bass), Albert Fox (fiddle), Gene Thompson (mandolin), Tom Murphy (guitar), and Tweed Donohoe (banjo). The members of this band reside in various parts of Northern Kentucky. The band's leader, Gene Thompson, also stages bluegrass shows in his hometown of Hebron, Kentucky. (Courtesy of Gene Thompson.)

Personable guitar player and vocalist Jim Hurst lives in Glasgow, Kentucky. Jim, who is an IBMA multi-year award-winning guitarist, is a regular on the Kentucky bluegrass circuit. When not playing music, Hurst avidly follows the University of Kentucky's football and men's basketball teams. (Courtesy of Senor McGuire.)

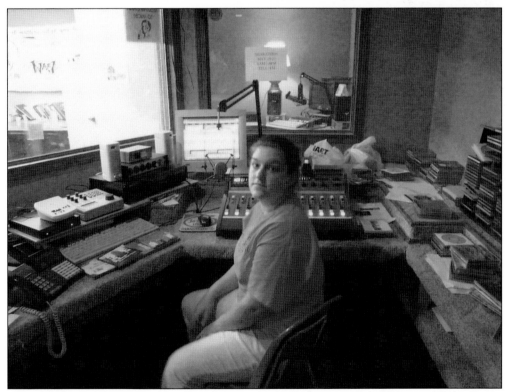

Elysa Durban is a disc jockey on FM radio station 98.7, which plays "Only Bluegrass All the Time," a broadcast outlet billed as the only totally bluegrass station in the United States. The station is located near Benton in western Kentucky, but because this station broadcasts on the FM radio band, its broadcast range is quite limited. (Courtesy of Dan Knowles.)

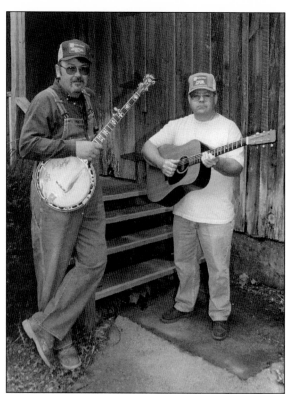

The popular comical bluegrass duo from Nicholasville, Kentucky, the Moron Brothers, got their start in the mid-1990s thanks to Kentuckian Dean Osborne, who discovered them. Both men are named Mike, so to avoid confusion Mike Hammonds (left) adopted the stage name of Lardo, and Mike Carr took the name Burley. They bill themselves as "purveyors of fine bluegrass since way back." (Courtesy of Gene Thompson.)

Bill Monroe certainly was not wasting his time when this picture was taken. Monroe is shown giving a music lesson to a very young and attentive Kentuckian, Chris Thile, in a 1995 picture taken in Owensboro, Kentucky. Thile later joined the popular acoustic trio Nickel Creek, a successful cutting-edge newgrass ensemble that added its own particular stamp to the sounds of bluegrass music. (Courtesy of Jim Peva.)

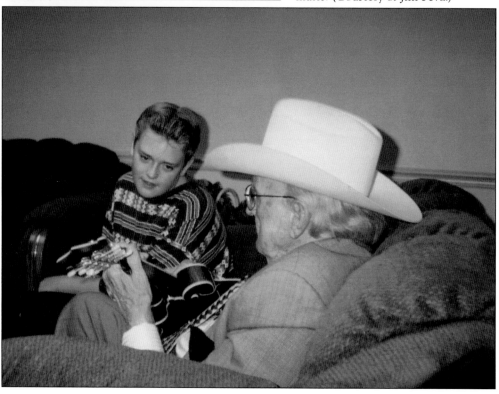

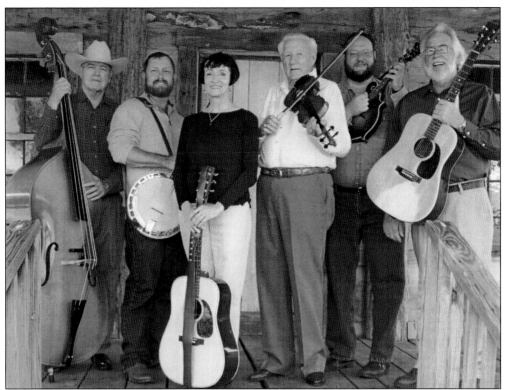

Southbound Highway is a band of veteran bluegrass musicians based out of Williamsburg, Kentucky. The band has a following of devoted fans, especially in central and southeastern Kentucky. From left to right are Dan Stamper (bass), Joe McClure (banjo), Merita Lee (vocals and guitar), Dean Huddleston (vocals and fiddle), Virgil Bowlin (mandolin), and John Vaught (lead vocals and guitar). (Courtesy of Merita Lee.)

The contemporary bluegrass band Bluegrass 101 is from Nelson County, Kentucky. Winner of the 2003 Bluegrass Battle of the Bands held at the International Bluegrass Museum in Owensboro, Kentucky, this band has recorded six albums. The band members, pictured with their instruments, include Terry Waldridge (guitar and lead vocals), Michael Yount (bass and baritone vocals), Ben Read (mandolin and bass vocals), Jim Armstrong (fiddle and tenor vocals), and Cody Pearman (banjo). (Courtesy of Bluegrass 101.)

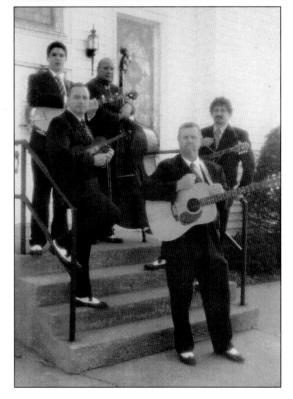

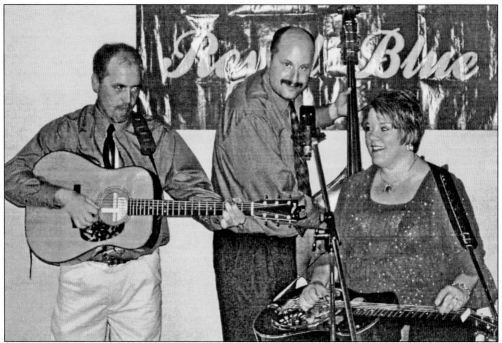

Shown in this picture are three members of the popular bluegrass band Royal Blue, a group based in Mercer County, Kentucky. This band is rapidly becoming a crowd favorite on the Kentucky bluegrass circuit. From left to right are band members Chris Goodlett (guitar), Rick Maxfield (bass), and Karen Maxfield (dobro). (Courtesy of Royal Blue.)

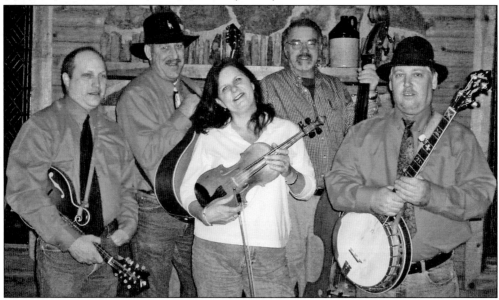

This is the eastern Kentucky–based contemporary bluegrass group Mike Havens and Blue Mountain Grass. The mandolin player and harmony singer is Keith Prater, Mike Havens (from Mize, Kentucky) is lead singer, songwriter, and guitar player, Debi Brandenburg Horton plays fiddle and sings harmony, the bass player is unidentified, and the banjo player is Mike Wilson. (Courtesy of Mike Havens.)

## Ten

# THE STARS OF TODAY AND TOMORROW

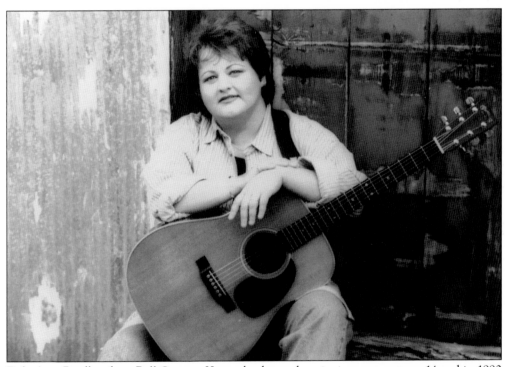

Dale Ann Bradley, from Bell County, Kentucky, began her singing career at age 14 and in 1990 joined the New Coon Creek Girls as lead singer and guitarist. In 1997, the group (which is no longer active) changed its name to Dale Ann Bradley and Coon Creek. Bradley, who is currently performing as an independent artist, was named the IBMA female vocalist in 2007, 2008, and 2009. (Courtesy of Pam Gadd.)

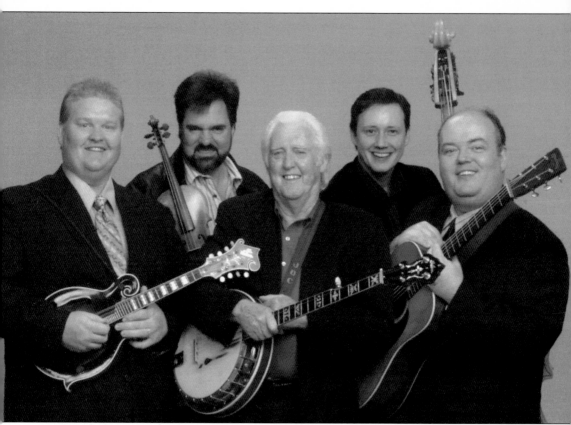

Legendary bluegrass musician J. D. Crowe is pictured here with the New South. From left to right are Dwight McCall (mandolin), Steve Thomas (fiddle), Crowe (vocals and banjo), John R. Bowman (bass), and Rickey Wasson (lead vocals and guitar). Crowe, a two-time winner of the IBMA Banjo Player of the Year award (1994 and 2004), was inducted into the IBMA Hall of Fame in 2003. In 2007, his album *Lefty's Old Guitar* won the IBMA's Album of the Year award. Crowe began his career in Mac Wiseman's band in 1955, and since 1968, he has played in bands he helped found or has headed. "J. D.," as he is known to his legions of fans, has performed all across America as well as in Europe. For the last nine years, Crowe has put his name to a bluegrass festival known as Crowe Fest, which is staged at a picturesque farm a few miles from his hometown of Nicholasville. (Courtesy of Rickey Wasson.)

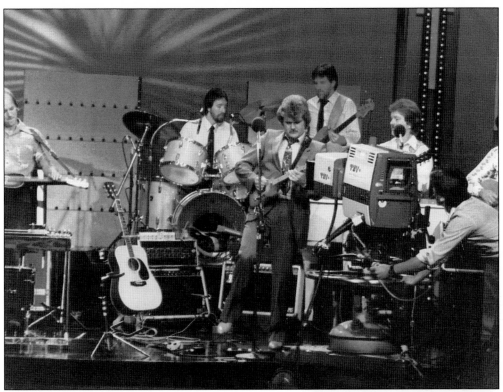

Kentuckian Ricky Skaggs is shown with his band during a live television performance. Skaggs performs lead vocals, plays several stringed instruments, and is shown playing his favorite instrument, the mandolin. Ricky Skaggs is arguably the best-known living bluegrass entertainer in the world. He has played with many of the greats, such as Bill Monroe, Ralph Stanley, and J. D. Crowe. He currently heads the band Kentucky Thunder, generally considered the finest entourage of musicians performing in any current bluegrass band. Skaggs has won multiple CMA, IBMA, and Grammy awards. During much of the 1980s and 1990s, he departed bluegrass music to perform as a country entertainer. However, in 1997, Skaggs returned to bluegrass with the release of his award-winning album *Bluegrass Rules*. Some consider Skaggs's rendition of Bill Monroe's song "Uncle Pen" to be an unofficial anthem of bluegrass music. (Courtesy of Tony Tackett of the Highway 23 Museum.)

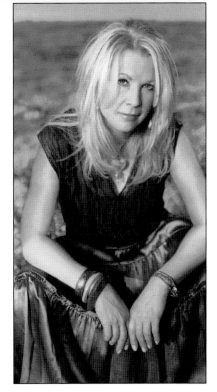

This is perennial country music award-winning vocalist Patty Loveless from Pikeville, Kentucky. Loveless recorded her first bluegrass album, *Mountain Soul*, in 2001, and performed on the Down from the Mountain Tour with both traditional and bluegrass artists. (Courtesy of Tony Tackett of the Highway 23 Museum.)

Blind fiddler Michael Cleveland's band is called Flamekeepers. Cleveland and his band are three-time winners of the IBMA's Instrumental Group of the Year award (2007, 2008, 2009). Two band members are from Kentucky: mandolin player Jesse Brock from Bowling Green is fourth from left, and at right is banjo player Jessie Baker, who lives in Georgetown. (Courtesy of the Flamekeepers.)

Bluegrass music legend Bobby Osborne, from Hyden, Kentucky, is shown performing with his band, the Rocky Top X-Press. Bobby, the oldest member of the famed bluegrass duo the Osborne Brothers, plays mandolin and is a tenor. He began his career in 1949 with banjo player Larry Richardson, Ezra Cline, and the Cline brothers in the Lonesome Pine Fiddlers where, in 1950, Bobby was joined by his 13-year-old banjo-playing brother, Sonny. By 1953, the brothers were performing on Detroit radio with Jimmy Martin; in 1956, they formed their own band and signed with MGM Records. They joined the *Opry* in 1964. The Osborne Brothers recorded their smash hit, "Rocky Top," in 1968, a song which in 1982 became the state song of Tennessee. They were CMA's vocal group of the year in 1971 and were inducted into the IBMA Hall of Honor in 1994. Following Sonny's retirement with a shoulder injury, Bobby formed his current band and signed with Rounder Records in 2005. Bobby also teaches music at the community and technical college in Hyden. (Courtesy of Mike Morbeck.)

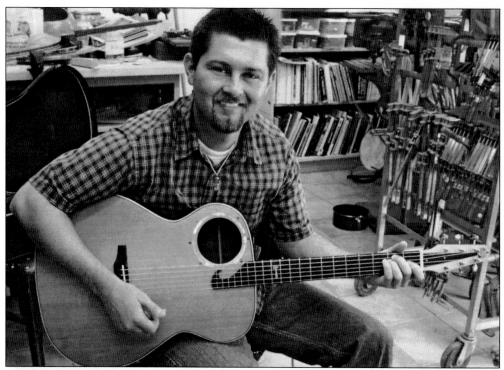

Kyle Reeder is a nationally known flat-pick and finger-style guitarist from Mayfield, Kentucky. Reeder, who has performed with various bluegrass bands in recent years, won the International Finger-style Championship in Winfield, Kansas, in 2008. He is considered to be one of the top performers in the field, and his services as a musician are in high demand. (Courtesy of Dan Knowles.)

Kati Penn, a skilled bluegrass fiddler player and vocalist from Lexington, Kentucky, began her musical career at age 12. Kati has performed on over 20 albums, and in 2001, she and fellow Kentuckian John Cowan were nominated for the IBMA's Best Instrumental award for their work on the Pinecastle Records series *Bluegrass 2001*. Penn also recently performed on Kentucky Educational Television's popular bluegrass show, *Jubilee*. (Courtesy of Kati Penn.)

Larry Cordle, an award-winning songwriter and musician, is from Cordell, Kentucky. Cordle, who won the 1993 IBMA award for Song of the Year, has written several hit songs for both country and bluegrass recording stars; he also won the CMA (2000 and 2001) and IBMA (2000) awards for Song of the Year. (Photograph by Becky Johnson.)

Dean Osborne hails from Lexington, Kentucky. Osborne is a tenor bluegrass singer and the cousin of Bobby and Sonny Osborne. He formed his first band, Thousandsticks, in 1980 and another in 1986 called East Bound; he now heads the Dean Osborne Band. In 2006, Osborne was appointed head of the bluegrass and traditional music program at Kentucky's Hazard Community and Technical College. He also shows Tennessee walking horses. (Courtesy of David Smith.)

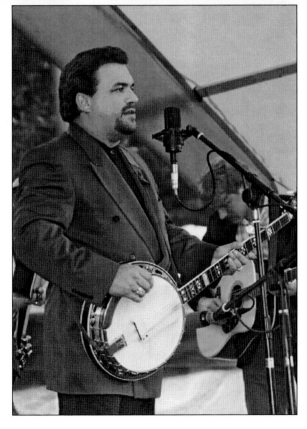

The bluegrass band Appalachian Grass is shown performing on stage in 2009 at Vernon McIntyre's bluegrass show in Wapakoneta, Ohio. The band's lead singer and guitarist is Jenny Plemen, from Grant County, Kentucky. Plemen began her professional career in music in 2007 and has developed a steadily growing fan base. (Courtesy of Vernon McIntyre and Jenny Plemen.)

Bawn in the Mash is an up-and-coming touring bluegrass band from Paducah, Kentucky. The band recently released its first album, *Welcome to the Atomic City*. From left to right are Tommy Oliverio (mandolin), Eddie Coffey (bass), Lathan Lynn, who is no longer with the band (guitar), and Josh Coffey (fiddle). (Courtesy of Eddie Coffey.)

The popular bluegrass band known as Sassafras is from Gallatin County, Kentucky. These youngsters started their performing careers under the tutelage of Kim Samuel, their music teacher at Gallatin County Middle School. From left to right are Turner Hutchens (mandolin), Maggie Lander (fiddle), Chloe Blayne (banjo), Amelia Samuel (bass), and Tyler Mullins (guitar). (Courtesy of Dale and Kim Samuel).

The Gallatin County Bluegrass Band features nine remarkably talented middle school and high school–aged musicians. Shown here are, from left to right, Amelia Samuel, Stacey Jones, Justin Alexander, Amber Boyers, Andrea Conley, Courtney Jones, Tyler Mullins, Chloe Roberts, and A. J. Webster. Kim Samuel is the group's founder as well as its ongoing musical instructor and mentor. (Courtesy of Dale Samuel.)

Perhaps this youthful bluegrass band from Horse Branch, Kentucky, on its way in to perform at the 2008 Jerusalem Ridge Bluegrass Celebration, is walking down the pathway to its future. Currently, there are several programs in Kentucky like the one from the school at Horse Branch teaching the next generation of bluegrass musicians their craft. (Courtesy of Mike Morbeck.)

Marie McGlone, a 12-year-old fiddle protégé whose mother Theresa is from Erlanger, Kentucky, is clearly having a great time playing with Ralph Stanley II at Carl Hammonds's 2009 bluegrass festival in Indianapolis, Indiana. McGlone, who began performing at age nine, has won and placed in fiddle contests in Kentucky, Tennessee, and Illinois. (Courtesy of Theresa McGlone Kenkel.)

Award-winning fiddle player Hunter Berry, who began fiddle at age four, makes his home in Lexington, Kentucky. He currently performs with his fiancé's mother, bluegrass star Rhonda Vincent. Before joining Rhonda Vincent and the Rage in 2002, Berry performed for nine months with Doyle Lawson and Quicksilver. (Courtesy of Mike Morbeck.)

These two Kentuckians, Tom T. Hall (left) and Josh Williams, have dedicated their lives to playing music. This picture was taken in Hall's Good Home Grown Music Studio in Franklin, Tennessee, in 2006. A songwriter and ballad singer, Tom T. Hall hails from Olive Hill, Kentucky. He learned guitar at age four and formed his own band, the Kentucky Travelers, at age 13. A prolific songwriter, Hall's biggest hit was "Harper Valley PTA" (1968). He recorded his hit bluegrass song "Fox on the Run" on an album in 1976, and Hall made a second bluegrass album in 1998. Tom T. Hall was inducted into the Country Music Hall of Fame in 2008. (Courtesy of Henry and Josh Williams.)

Josh Williams, a dynamic vocalist and guitar player from Benton, Kentucky, was the IBMA guitarist of the year in 2008 and 2009. Williams, who previously performed with Rhonda Vincent and the Rage (2003–2007), now heads the Josh Williams Band, a group that is enjoying enormous success and popularity. He was one of bluegrass music's child prodigies. He gained national recognition with an appearance on the 1993 IBMA awards show in the Bluegrass Youth All-Stars, a talented ensemble that also featured Chris Thile from Murray, Kentucky. Williams recorded his first album in 1991 and from 1994 to 1998 performed with the Young Acoustic All-Stars. Williams played with three other bands before joining Rhonda Vincent and the Rage. Williams plays all the bluegrass instruments but began as a banjo player at age eight. (Courtesy of Henry and Josh Williams.)

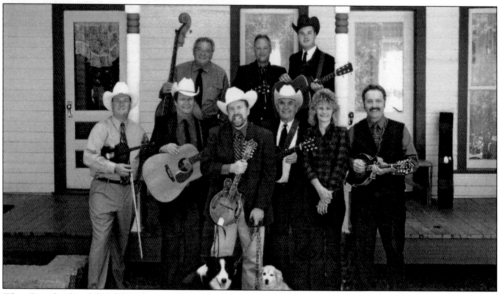

The Cumberland Highlanders are bluegrass musicians (some of whom are from Kentucky) who combined have over 250 years of experience performing. From left to right are (first row) Steve Day (fiddle), Wayne Lewis (guitar), Doc Campbell Mercer (mandolin), Joe Issacs (guitar), Stacy York (vocals), Jackie Kincaid (mandolin); (second row) Jim Rigsby (bass), Lynwood Lunsford (banjo), and Kody Norris (guitar). Doc Campbell Mercer, who plays guitar and sings leads, has been involved in bluegrass music most of his adult life. He resides with his wife, Julie, and their two daughters in a house on Jerusalem Ridge just outside Rosine, Kentucky, on land that was owned by the Monroe family. Doc also produces a popular bluegrass television show on RFD-TV. (Courtesy of Mike Morbeck.)

Jamie Dailey was born in Corbin, Kentucky. He began singing with his family at age three, played bass in his family's band at age nine, and at age 12 played banjo with them. He next joined Cumberland Connection, after which he worked with two other bluegrass groups. Dailey's career began to take off once he joined Doyle Lawson and Quicksilver (1998–2007). (Courtesy of Mike Morbeck.)

Jamie Dailey (seated) and Darrin Vincent are bluegrass music's hottest new act. Both men were stars with other bluegrass bands—Dailey with Doyle Lawson and Vincent with Ricky Skaggs. Since they joined together as Dailey and Vincent in 2007, they have taken the bluegrass world by storm, receiving an astounding six IBMA awards in 2008 and three more in 2009. (Courtesy of Don Light.)

# DISCOVER THOUSANDS OF LOCAL HISTORY BOOKS FEATURING MILLIONS OF VINTAGE IMAGES

Arcadia Publishing, the leading local history publisher in the United States, is committed to making history accessible and meaningful through publishing books that celebrate and preserve the heritage of America's people and places.

## Find more books like this at
## www.arcadiapublishing.com

Search for your hometown history, your old stomping grounds, and even your favorite sports team.

Consistent with our mission to preserve history on a local level, this book was printed in South Carolina on American-made paper and manufactured entirely in the United States. Products carrying the accredited Forest Stewardship Council (FSC) label are printed on 100 percent FSC-certified paper.

MADE IN THE USA